IMAGES
of America

PLAZA-MIDWOOD
NEIGHBORHOOD
OF CHARLOTTE

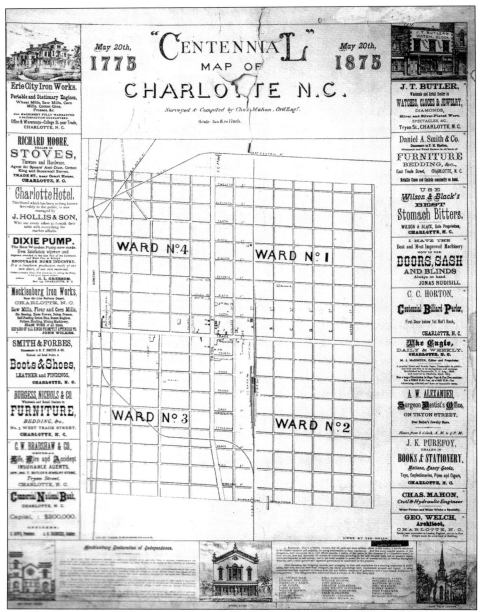

This 1875 map of Charlotte's four "wards" celebrates the centennial of the Mecklenburg Declaration of Independence, an apocryphal document the authenticity of which is still a local bone of contention. Among the advertisements for stomach bitters and shoes are early indications of Charlotte's emerging New-South economy—manufacturing and banking. The Commercial National Bank boasting of $200,000 in assets would like many other small financial institutions merge and grow to make Charlotte the second-largest financial center in the nation. The Mecklenburg Iron works located on East Trade Street was one reason the Confederate States shipyard had "dry-docked" in the small town of Charlotte. (Courtesy of the Robinson-Spangler Carolina Room, Public Library Charlotte-Mecklenburg County [PLCMC].)

IMAGES
of America

PLAZA-MIDWOOD
NEIGHBORHOOD
OF CHARLOTTE

Jeff Byers

ARCADIA

Published by Arcadia Publishing
Charleston SC, Chicago IL, Portsmouth NH, San Francisco CA

Printed in Great Britain

Library of Congress Catalog Card Number: 2004108247

For all general information contact Arcadia Publishing at:
Telephone 843-853-2070
Fax 843-853-0044
E-mail sales@arcadiapublishing.com
For customer service and orders:
Toll-Free 1-888-313-2665

Visit us on the internet at http://www.arcadiapublishing.com

In loving memory of "Miss Pearl" Sanger from your Nassau neighbors—
"Hello over there!"

"Miss Pearl" Sanger was a beloved neighbor who made her home in Plaza-Midwood for over 60 years. Her passing in 2004 was marked by an outpouring of cards, flowers, and candles on the steps leading to her front yard, where many neighbors passed summer evenings in her loving presence.

CONTENTS

ACKNOWLEDGMENTS

This book would not have been possible without the help of many people. Professionally and personally, thanks to all who assisted me: to Sheila Bumgarner and Jane Johnson at the Charlotte Mecklenburg Public Library's Carolina Room, much appreciation; to Pat Ryckman and Marilyn Schuster at UNC-Charlotte's Atkins Library Special Collections; to Ryan Sumner of the Levine Museum of the New South and especially to Dr. Tom Hanchett of the Levine Museum whose work, *Sorting Out the New South City*, has so well documented Charlotte's suburban development; to Dr. Dan Morrill for his influential and painstaking scholarship; to Dennis Lawson and Sheila Christopher of the Duke Energy archives; and to Byron Baldwin who graciously shared his photographs of Plaza-Midwood. Personally, I would like to say thanks to Aaron Gay and Garrett Ladue for discovering Arcadia's call for authors. Also, thanks go to Garrett for all the technical help, along with George Warren, Jeff Bame, Rich Snyder, and Jodi Iaquinta; to Marshall and Charlotte Waldron, Kathy Matthews, and Buddy Gosnell, my Nassau neighbors; to families and churches for sharing photographs and memories, especially Corky Ingram at Holy Trinity; to Frances and Bill Gay, Mary Ann Hammond, and other Plaza-Midwood people who assisted with memories and images; and finally, to Charles Paty, who *is* the memory of Plaza-Midwood.

INTRODUCTION

Plaza-Midwood's story is Charlotte's story. This historic neighborhood has gone from farmland to streetcar suburb to urban-renewal success in the century since its development first began. And like Charlotte as a whole, the neighborhood continues developing and reinventing itself. It is a story of New-South dreams. Some came to fruition, some were delayed, and some were never realized. Ultimately, it is the story of a dream undergoing restoration—like so many of its private homes and public buildings.

At the turn of the 19th century, Charlotte began emerging from its role as a local market for agricultural goods. Not more than a rural hamlet of a few hundred inhabitants prior to the Civil War, Charlotte was fast becoming a leader in the New-South version of the cotton economy. Even so, the city remained up until the this time a circle of tightly packed wards surrounding Independence Square at the crossing of Trade and Tryon Streets—an area now surrounded by I-277. It was cotton money and an abundance of sparsely populated land on the edge of those wards that enabled Plaza-Midwood's development. At the time developers began eyeing the high ground on the edge of Charlotte's First Ward, the future Plaza-Midwood consisted of a patchwork of landholdings surrounding the Louise Mill and the privately owned residences of the Belmont and Optimist Park neighborhoods. By the early 1900s, developers such as B.D. Heath and Paul Chatham had begun plans leading to the development of parts of Elizabeth and Plaza-Midwood.

With the beginning of electric streetcar service, Charlotteans were no longer limited in trade, work, and recreation by proximity to their homes. Developers could use the streetcar service to entice folks to move both from the confines of the four wards and from the surrounding countryside to be closer to Charlotte's ever-expanding economy and amenities. Plaza-Midwood also serves to illustrate the importance the role of "mover and shaker" plays in Charlotte's development and public life. The neighborhood's growth was both spurred and hampered by the conflicts and machinations of Charlotte's New-South elite. Unfortunately, Plaza-Midwood's story is also a reminder of how Charlotte has too often considered its past disposable in the face of "progress" and "improvement." Only fairly recently has the city begun a concerted effort to preserve its past.

Ultimately, "Midwood"—as the neighborhood is often referred to unofficially today—tells a story of neighbors: neighbors who, through hard work, vision, and a sense of community, have sought to restore what could easily have become another tale of inner-city decline. This hard work and vision led to both the naming and saving of a neighborhood so crucial to understanding Charlotte and the New South—both past and future versions.

The purpose of this work is to document and honor this unique and historic neighborhood, so beloved by those who stroll its cool, shaded sidewalks; shop, dine, and drink in its diverse business district; restore and preserve its homes; and engage each other in the true sense of the word "neighbor." Hopefully, it will put neighbors present in closer touch with neighbors past.

One

STRAWBERRY FIELDS TO STREETCARS

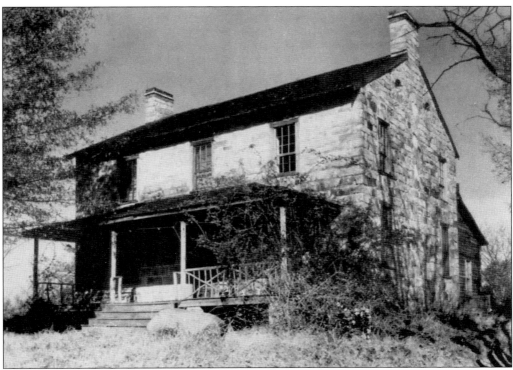

Not much is known about this rural Mecklenburg farmhouse beyond the surname of its original family. The Wallis family represented a middling class of rural Mecklenburg farmers whose homesteads dotted the areas on the fringe of Charlotte's city limits in the 1800s. Families such as the Wallises sold off pieces of their landholdings to developers like Paul Chatham, who hoped to turn a strawberry field into a posh suburb. (Courtesy of the Robinson-Spangler Carolina Room, PLCMC.)

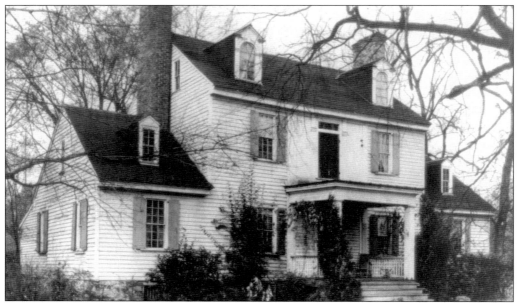

Historic Rosedale still stands on North Tryon Street just outside of downtown Charlotte. Its owners were members of the old planter class. Rosedale is one of the best-preserved historic dwellings in Mecklenburg County. The plantation bordered the land holdings of other agricultural families, including those of the Phifer, Pegram, and Seigle families. These three families were instrumental in the development of Belmont and Villa Heights, which border Plaza-Midwood to the north and west. (Courtesy of the Robinson-Spangler Carolina Room, PLCMC.)

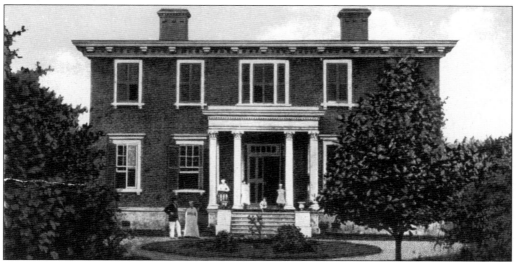

The Phifer house stood on the eastern edge of Charlotte prior to the Civil War. The plantation was located in the blocks between Ninth and Eleventh Streets just outside of downtown Charlotte. It was the scene of the last meeting of the Confederate cabinet in 1865. The Phifers' land extended north and east of the area near Plaza-Midwood that became known as Belmont Springs. Cordelia Park, just outside of Belmont, is named after Cordelia Phifer. (Courtesy of the Robinson-Spangler Carolina Room, PLCMC.)

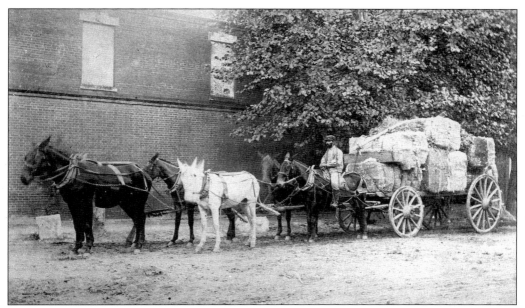

This wagonload of cotton illustrates the dependency on cotton in the New South. The families who owned the land outside Charlotte were not limited to producing cotton. Farmers also raised produce such as strawberries or raised dairy cattle. As rural people moved into a growing Charlotte at the close of the 1800s, they brought their agricultural skills to the mill villages and suburbs, often keeping chickens and milk cows within the city limits. (Courtesy of the Robinson-Spangler Carolina Room, PLCMC.)

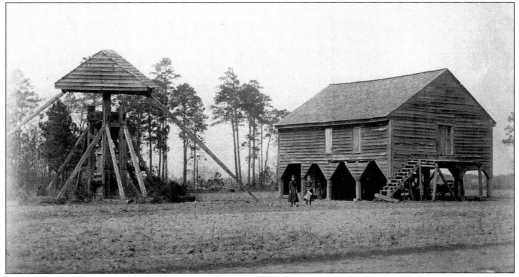

Cotton gins like this c. 1900 one in Mecklenburg County represented the power of available capital. Only those who went into the post–Civil War era with ready capital could afford to erect facilities like this on their farms. They could charge their tenants and local farmers a fee to gin cotton prior to market. Gin owners could then invest in mercantile ventures such as general stores or in the emerging textile industry. (Courtesy of the Robinson-Spangler Carolina Room, PLCMC.)

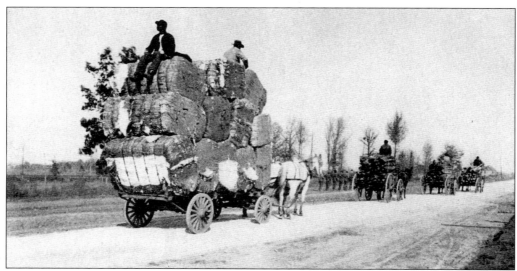

This c. 1900 cotton dray was the transfer truck of its day. Ownership of these "trucks" could mean the ability to bring bigger loads of cotton to market quicker and the ability to charge others for their use. The image is taken from a postcard series featuring roads in rural Mecklenburg. Central Avenue, or "Lawyer's Road" as it was called at the time, would have had a similar appearance. (Courtesy of the Robinson-Spangler Carolina Room, PLCMC.)

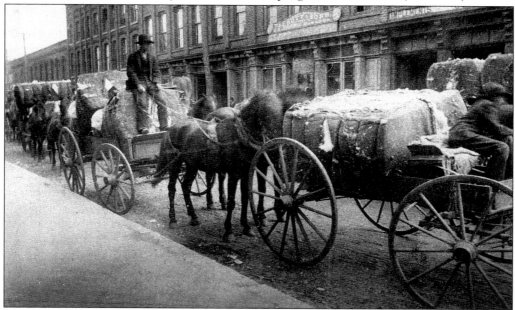

Charlotte was fast becoming the hub for cotton distribution in the early 20th century. Charlotte's growing textile mills and supporting industries would draw rural folk in search of a secure—if small—weekly wage. Rural folks from Mecklenburg and throughout the region found home sites in the Plaza-Midwood area. Likewise, city dwellers in Charlotte's four wards also found homes in Plaza-Midwood's cottages, bungalows, and mansions during the first half-century of the neighborhood's development. (Courtesy of the Robinson-Spangler Carolina Room, PLCMC.)

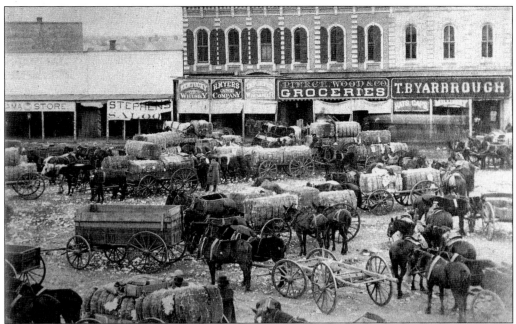

These two *c.* 1898 images show cotton going to market in Charlotte. In the top photo, farmers' wagons are parked along a commercial strip of a saloons and grocers. Many store owners gained enough capital to diversify their investments into cotton mills, banking, and real-estate development. B.D. Heath—developer of Oakhurst in present-day Plaza-Midwood's historic district—was a mentor for John Belk, who began his retail empire as an assistant in Heath's Monroe, North Carolina mercantile. The bottom image shows the progress of cotton drays down what may be Tryon Street. (Courtesy of the Robinson-Spangler Carolina Room, PLCMC.)

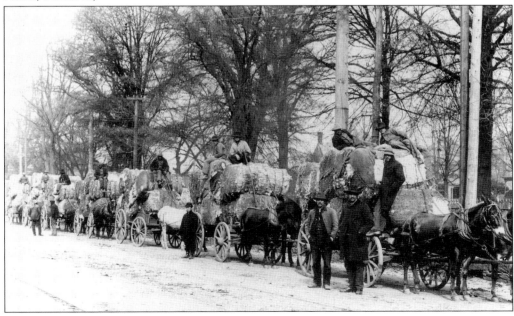

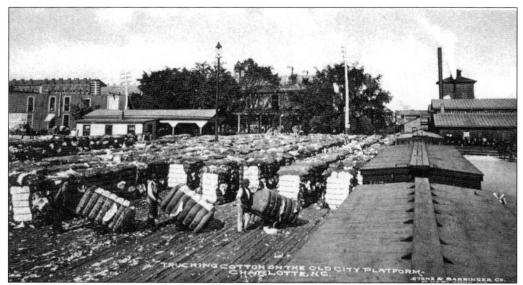

Charlotte's emergence as a town of consequence was based on its railway connections. Charlotte would have remained a village without the coming of railway lines in the 1850s, and rail connections at the end of the 19th century brought Charlotte economic growth. These cotton bales are ready for loading near the Southern Railway depot. Rail lines meant prosperity for Charlotte, but they hampered development in the areas Plaza-Midwood now comprises, slowing streetcar commutes. (Courtesy of the Robinson-Spangler Carolina Room, PLCMC.)

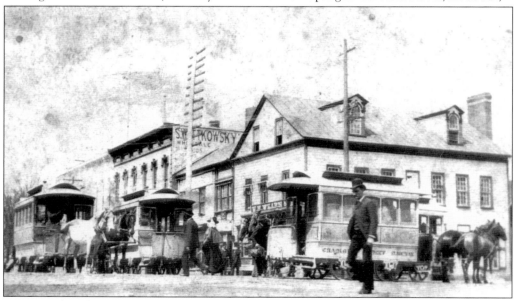

In years after this c. 1890s photo, electric streetcar service extended to suburbs developed around the tracks. After Dilworth, Plaza-Midwood, Elizabeth, and Myers Parks all developed as a result of this technology. Infighting for streetcar system control influenced development and set residential patterns in north and southeast Charlotte for years to come. Plaza-Midwood had a small and inadequate streetcar line built by Paul Chatham, and therefore developed slower than Dilworth and Myers Park. (Courtesy of the Robinson-Spangler Carolina Room, PLCMC.)

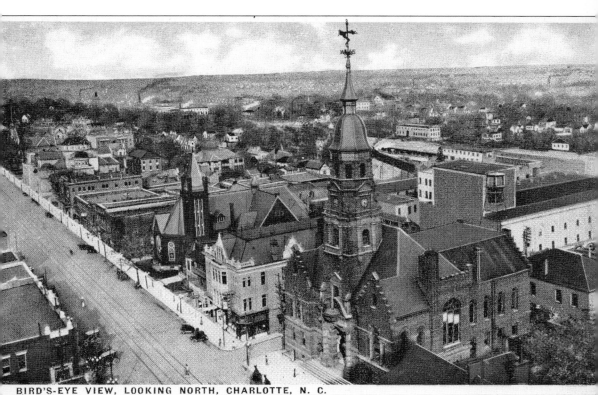

BIRD'S-EYE VIEW, LOOKING NORTH, CHARLOTTE, N. C.

This *c.* 1900s view from the Tompkins Tower takes in the edges of the Fourth and First Wards. In the distance, along today's North Tryon and Parkwood Road corridor, the smoke stacks of the nascent textile industry can be seen along with hints of surrounding residential structures. These mills and their villages, along with related manufacturing plants, helped to stimulate Charlotte's growth, but the same industries that stimulated growth may have slowed it in Plaza-Midwood. Although many wealthy Charlotteans would move into the Plaza-Midwood area over the course of its development, pristine pastureland free of the cotton-mill taint was waiting to be had near the city's southeastern edge. (Courtesy of the Robinson-Spangler Carolina Room, PLCMC.)

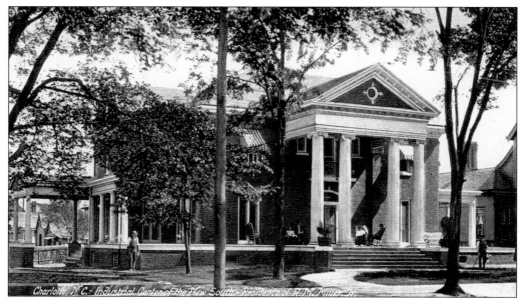

This 1909 mansion stood at the corner of Seventh and Tryon Streets. Robert M. Miller, a prominent Charlotte businessman, owned this lot in the 400-block of North Tryon and Seventh Streets facing today's Saint Peter's Episcopal Church. On the same block, Robert M. Miller built twin Queen Anne Victorian homes for his sons. To accommodate the new mansion's grounds, Miller moved his son John's home to a Chatham Estates lot on the Plaza in 1915. (Courtesy of the Robinson-Spangler Carolina Room, PLCMC.)

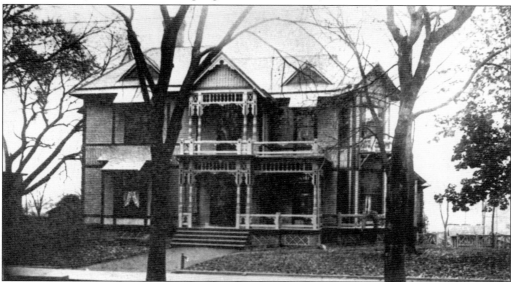

This handsome c. 1890s house belonged to John and Mary Oates Spratt Van Landingham. East Avenue (East Trade Street) was once a fashionable address. The Van Landinghams were socially prominent and involved in the cotton economy. A formidable and intelligent woman, Mrs. Van Landingham helped organize the drive for medical facilities in Charlotte. Her son Ralph built the most imposing home in Plaza-Midwood. Like most residences uptown, the home was demolished. (Courtesy of the Robinson-Spangler Carolina Room, PLCMC.)

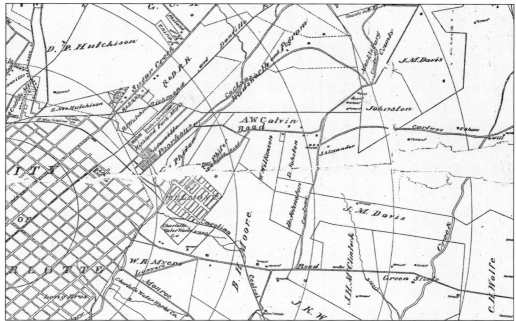

This 1892 survey map shows the commercial and residential areas off Trade and Tryon Streets. Mill villages occupied Charlotte's northeastern edge for some years before developers looked to the area. B.D Heath was one of the first to realize the area's potential, buying farmland along the Seaboard Airline railway. Following its present path adjacent to Plaza-Midwood's northern boundary, Poorhouse Road—now Parkwood Avenue—turned on what is today Thirty-sixth Street to the county poorhouse. To the south, Lawyer's Road led to eastern Mecklenburg's farmlands. (Courtesy of the Robinson-Spangler Carolina Room, PLCMC.)

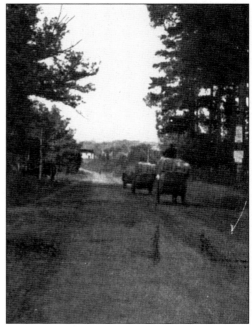

This is Monroe Road c. 1900s. What was then a rural road into Charlotte from eastern Mecklenburg County is now a major artery into the Plaza-Midwood, Elizabeth, and Chantilly neighborhoods. The picture was taken around the time development began on Paul Chatham's newly acquired land off Central Avenue. Central Avenue would have had a similar look before its development in the late 1890s. (Courtesy of the Robinson-Spangler Carolina Room, PLCMC.)

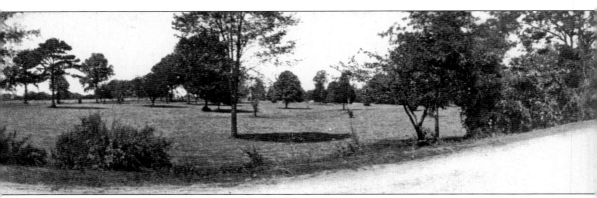

Note the surrey carriage in this 1900s view of Providence Road, when it was no more than a country lane. Plaza-Midwood's Pecan Avenue was at the time a dirt wagon-path connecting to Providence. Perrin Henderson, who grew up in Plaza-Midwood during its early years, recalls that the family farm occupied a section of Providence Road near Perrin Place in southeast Charlotte. His father chose to build his own first home near Plaza-Midwood in 1934, off Commonwealth Road. At the time there was a large dairy farm across the then-unpaved street. Today, a large condominium complex takes up the area. (Courtesy of the Robinson-Spangler Carolina Room, PLCMC.)

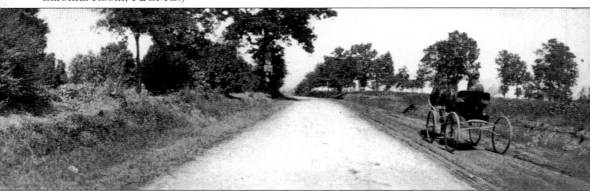

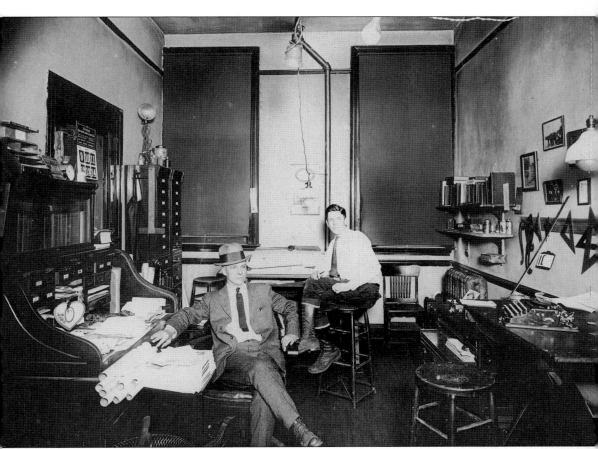

The man on the bottom left in this *c.* 1900s image is civil engineer Charles Guernsey Hubble at his Tryon Street office. The name of his assistant is unknown. Hubble was a native of upstate New York but spent most of his adult life in Charlotte. He was responsible for surveying plots in Plaza-Midwood and Elizabeth. He resided on Sunnyside in Piedmont Park (Elizabeth) until his death in 1954 at age 81. (Courtesy of the Robinson-Spangler Carolina Room, PLCMC.)

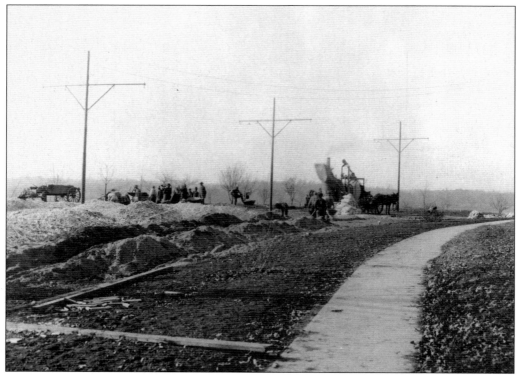

As of this writing no known images of the Plaza-Midwood area prior to development exist. The Myers Park development in southeast Charlotte, however, was well documented. One can see the daunting tasks faced by developers of these early streetcar suburbs. The early 1900s image above shows the laying of trolley track adjacent to new sidewalks in Myers Park. At the bottom, what appear to be embankment supports have been erected in anticipation of the streetcar track. (Courtesy of the Robinson-Spangler Carolina Room, PLCMC.)

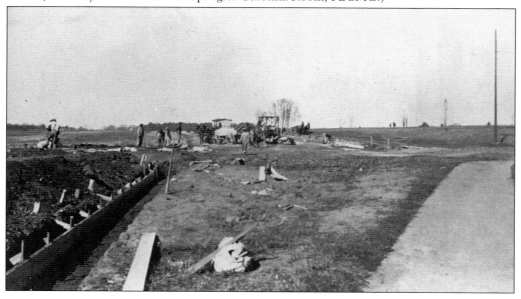

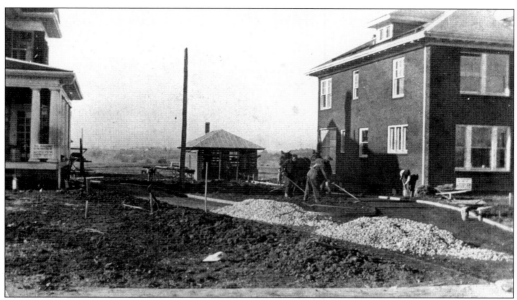

The top image shows homes in Myers Park shortly after construction. Like Plaza-Midwood, Myers Park is known for its lovely tree-canopied streets. George Stephens, Myers Park's developer, arranged for mature trees from his father-in-law J.S. Myers's farm. Paul Chatham engaged noted landscape designer John Nolen to shape his vision of Chatham Estates. Nolen's Chatham Estates plan called for greenway parks near Mimosa and the Plaza and between Nassau Boulevard and Tippah Avenue. The bottom image shows completed trolley tracks offset to one side of this Myers Park Street. The trolley running from the Plaza to Mecklenburg Avenue and out to the Charlotte Country Club ran to one side of the street allowing automobile traffic. (Courtesy of the Robinson-Spangler Carolina Room, PLCMC.)

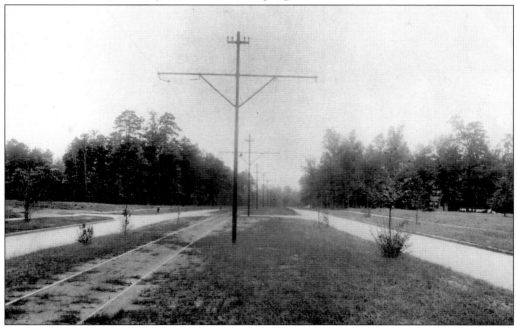

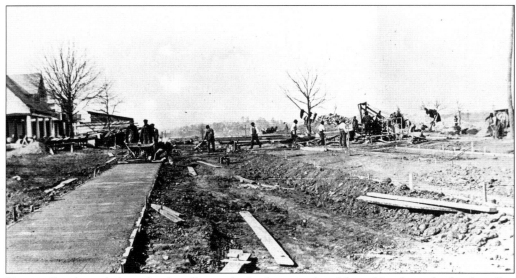

George Stephens believed sidewalks made for better sale of lots. He also subsidized trolley service to Myers Pak, unlike Paul Chatham to his namesake Estates. Here the sidewalk is apparently finished prior to the roadbed or trolley track. Myers Park developed at a more consistent rate than Plaza-Midwood, and attracted a wealthier, more homogenous clientele. Stephens' great business sense and planning coupled with easier streetcar connections also played a factor in Myers Park's steadier development. Chatham relied on his social connections and the proximity of the Charlotte Country Club to attract potential buyers. Unfortunately for his plans, this could not outweigh the inconvenience of commuting to Chatham Estates. In this *c.* 1910 view of a completed home site on Hermitage Court in Myers Park, a sidewalk flanks the street in anticipation of platting lots. (Courtesy of the Robinson-Spangler Carolina Room, PLCMC.)

Two

NEW SOUTH
Movers and Shakers

The planter class was not so much replaced as it was morphed by the New-South economy into the "textile baron." Other industries grew up a result of the textile boom. Banking, communications, food manufacturing, retail, and real-estate development in Charlotte all resulted from textile capital. Textile innovator D.A. Tompkins "brought the mills to the cotton." He improved manufacturing machinery and extended his influence by publishing the *Charlotte Observer*. At its peak his company consisted of 100 facilities. On paper, his "mill villages" were working-class suburbs. They were self-contained, with stores, churches, athletic fields, and recreation halls all within company property. The cotton economy directly impacted Plaza-Midwood; the capital created helped finance its development, and the proximity of mills and their villages influenced the neighborhood's character and served as a detriment to its development as a posh suburb *a la* Myers Park. (Courtesy of the Robinson-Spangler Carolina Room, PLCMC.)

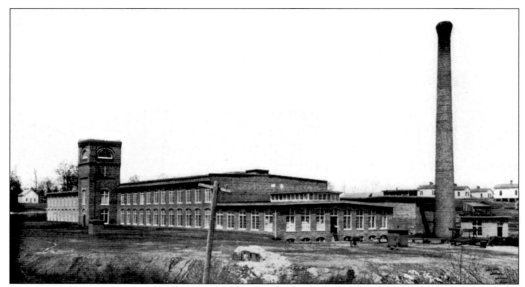

Cotton mills helped rural Southerners make hard cash. The influx of these rural strangers often offended the sensibilities of Charlotte's "better" citizens, who spoke out against poor whites with almost as much vitriol as they used against African Americans. Many townspeople saw the growing populations of "lint heads" as a cause for alarm. Proximity to manufacturing plants and the hands that operated them often kept middle-class and wealthy buyers away from Plaza-Midwood. (Courtesy of the Robinson-Spangler Carolina Room, PLCMC.)

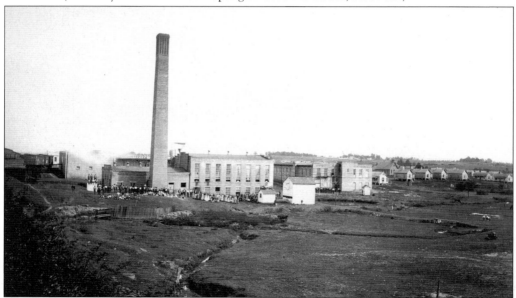

Highland Park Mill #1 still stands on Charlotte's North Tryon Street northwest of Plaza-Midwood. It was built in 1891 adjacent to the Belmont and Villa Heights neighborhoods. In classic Tompkins planning trim rows of houses neatly line up around a church with what must have surely been a pro-management preacher. In the foreground can be seen a reminder of rural tradition evidenced by the grazing cow. (Courtesy of the Robinson-Spangler Carolina Room, PLCMC.)

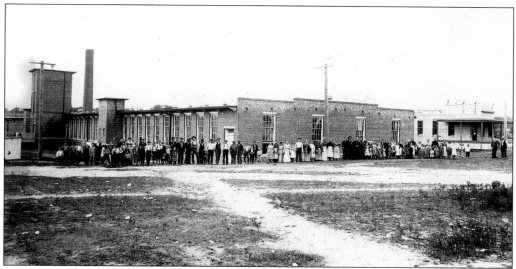

H.S. Chadwick named the Louise Mill in honor of his wife. Both mill and village were developed by B.D. Heath, who foresaw the area between Central and Hawthorne becoming a major industrial quarter. The mill and its village were adjacent to Belmont, part of Heath's Oakhurst development. The mill was the scene of labor unrest and rough treatment over workers resisting small pox vaccines. Unpleasant associations probably deterred more elite development, so Heath wisely turned development over to more modest home sites. (Courtesy of the Robinson-Spangler Carolina Room, PLCMC.)

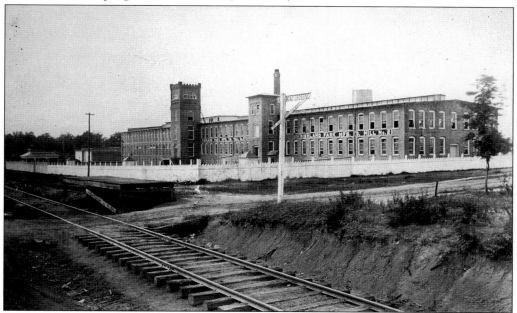

This view of the Highland Park Mill #2 illustrates the importance to mills of railway access, but rail lines would cut east Charlotte off from downtown until the 1930s, when overpass bridges became more common. The Seaboard Airline Railway crossing near Central and Hawthorne still causes traffic delays, albeit more rarely. (Courtesy of the Robinson-Spangler Carolina Room, PLCMC.)

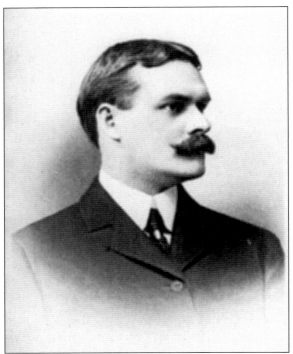

Stuart Cramer pioneered textile mill design, equipment, and processing, especially in the area of coolant systems. He established the mill town of Cramerton in Gaston County, but he made his home in Charlotte. He was instrumental in bringing the Charlotte Country Club to its present location in east Charlotte on the edge of Plaza-Midwood. (Courtesy of the Robinson-Spangler Carolina Room, PLCMC.)

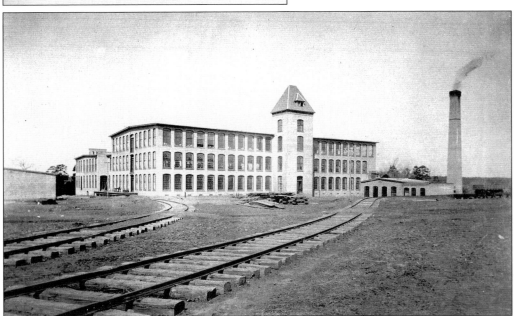

Yarn was produced by this Tompkins-owned mill. Other area mills produced finished clothing products, and Charlotte was known as the "trouser capital of the South". Plaza-Midwood developer Paul Chatham was involved in several clothing manufacturing concerns. The Piedmont region of North and South Carolina came to replace New England as the nation's chief producer of yarn, thread, and finished goods such as towels, sheets, and underwear. (Courtesy of the Robinson-Spangler Carolina Room, PLCMC.)

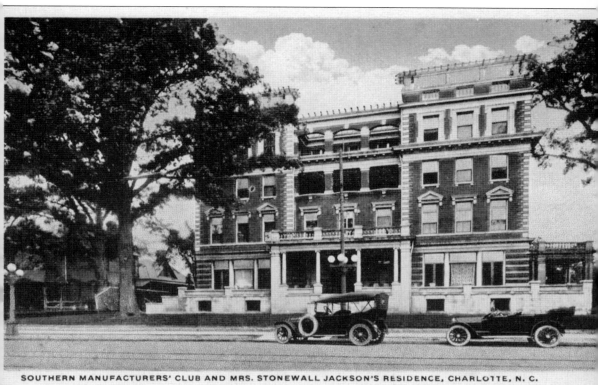

SOUTHERN MANUFACTURERS' CLUB AND MRS. STONEWALL JACKSON'S RESIDENCE, CHARLOTTE, N. C.

The Southern Manufacturers Club was located on South Tryon near the home of Charlotte's beloved Anna Morrison Jackson, widow of Confederate Gen. Stonewall Jackson. Here Charlotte's business elite could meet to work up deals or quench a thirst with bootleg alcohol in dry Mecklenburg County. Ironically, it was mill owners and other elite who so vehemently supported prohibition laws. The club was actually cleared of wrongdoing in a case involving alcohol. Apparently in keeping with their paternalistic notions, only the well heeled could drink (or vote) responsibly. (Courtesy of the Robinson-Spangler Carolina Room, PLCMC.)

The Cole family purchased a large plot of land along the Seaboard Railway Line from B.D. Heath to build their farm-implement factory. The bottom view of the Cole Manufacturing Facility shows the Seaboard Railway Depot for loading the farm implements for which Cole Manufacturing was known worldwide. The firm went out of business, but the property is still in use as office space. The area adjacent was developed by the Coles as Central Plaza, a direct response to suburban shopping malls like Park Road Shopping Center. The shopping center was home to an A&P food store and the second location of the budding Family Dollar chain. In that competition the malls won out, especially as inner-city neighborhoods like Plaza-Midwood and Dilworth went in to general decline during the 1970s and 1980s. Today, the plant itself is well preserved and used for high-end office space. (Courtesy of Garrett Ladue.)

B.D. Heath, president of the Charlotte National Bank, was the first to develop Plaza-Midwood. Shortly after the completion of Heathcote, designed by architect Frank Milburne, Heath turned his attention to the areas previously sold to the Chadwick, Barnhardt, and Cole manufacturing concerns along Hawthorne Lane. Oakhurst, as the neighborhood was known, was designed by Heath to accommodate housing for the "middling" classes who did not receive company-built homes in exchange for their labor and the labor of their children. (Courtesy of the Robinson-Spangler Carolina Room, PLCMC.)

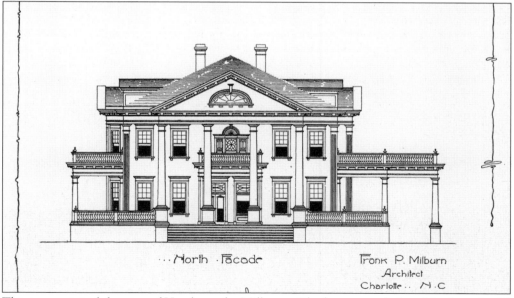

This is an original drawing of Heathcote by Milburne. The home was designed in the colonial revival style popular at the close of the 19th century and the early 1900s. Like many of Central Avenue's grand homes, Heathcote was demolished to make way for commercial development. It represented the fruition of the Heath family's land and mercantile ventures. (Courtesy of the Robinson-Spangler Carolina Room, PLCMC.)

This 1905 photo of livery stable owner Thomas Hoover shows the home of music store owner Charles Parker (built 1904). The house still stands on Central Avenue, at the time unpaved and called Lawyer's Road. Central Avenue was a high-end residential area and served, as it does today, as the retail center for Plaza-Midwood (Courtesy of the Robinson-Spangler Carolina Room, PLCMC.)

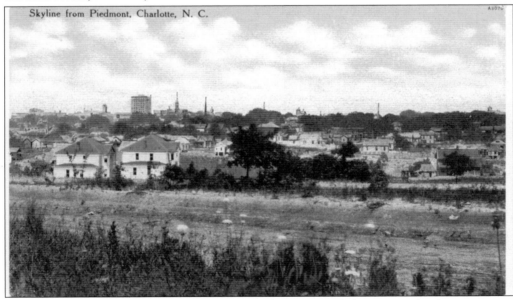

This postcard view of Piedmont Park looks northwest toward downtown. At the time many of the tallest structures were still church steeples. The street in the foreground could be Central Avenue. The homes are examples of the large houses that once lined the street before its intersection with Hawthorne Lane. (Courtesy of the Robinson-Spangler Carolina Room, PLCMC.)

This map of Piedmont Park shows the proximity of the development to Plaza-Midwood's Oakhurst section, which occupied much of the neighborhood's historic district. In the upper right hand corner, at the intersection of Central and Hawthorne, Heathcote and the large tract of land owned by B.D. Heath can be seen. This holding extended along Louise Avenue and further east on Central to the site of the present Cole Manufacturing facility. (Courtesy of the Robinson-Spangler Carolina Room, PLCMC.)

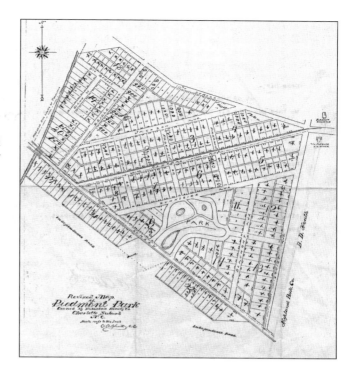

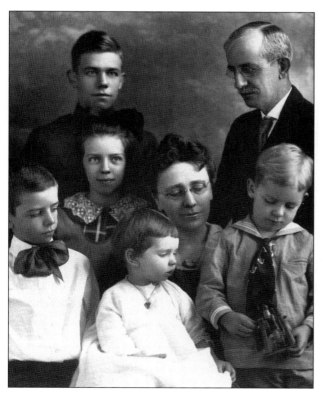

This *c.* 1900 portrait shows Thomas Marshall Barnhardt, his wife Caroline, and their children: Thomas Jr. (top left), Nell (in front of Thomas Jr.) Mary Gwynn (on Caroline's lap) Jacob (on Caroline's right), and James (on her left). Thomas Sr.'s ancestors fled the Rhineland in the 1700s and settled in Mecklenburg County. They became storeowners and parleyed their initial capital into cotton dollars. Beginning in 1899 or 1900 in his factory on Hawthorne Avenue, Barnhardt turned other manufacturers' cotton waste into cushioning. Later the company expanded into medical dressings and foam cushioning technology. (Courtesy of Barnhardt Industries.)

31

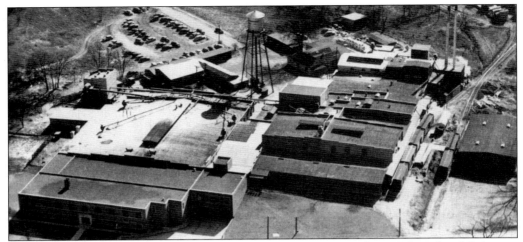

This aerial view of Barnhardt industries shows its situation near Plaza-Midwood and Belmont. Barnhardt Industries, like Cole Manufacturing, was built on land owned by the Heath family and took great advantage of the Seaboard Railroad. Barnhardt produced medical dressings crucial to hospitals and war efforts. The family is still very much in control of the business and takes a hands-on approach to management. The bottom image shows a part of the facility used for processing Barnhardt products. (Courtesy of Barnhardt Industries.)

When most young women of means were
content to marry well or play the socialite,
"Miss Nell" was crucial to the health of her
family business. Seen here c. 1940s, Nell
Barnhardt, a Duke graduate, took control of
Barnhardt's Richmond Dental Products
Division, supervising the business's move to
Charlotte. She devoted time to charity and
maintained the family home off Central
Avenue at a time when many were moving to
newer wealthy suburbs in southeast Charlotte.
(Courtesy of Barnhardt Industries.)

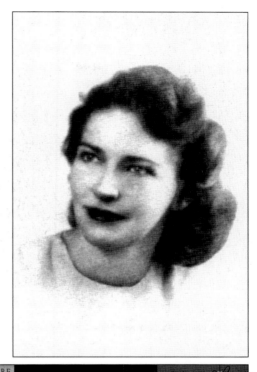

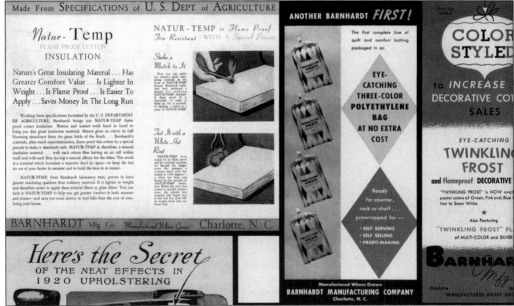

This c. 1940s–1950s promotional poster gives an idea of the diverse products produced by
Barnhardt. Many of these products were crucial to U.S. war efforts and medical procedures.
Barnhardt's diversity has extended to the furniture industry and foam cushioning. The firm
employed many people in the Belmont and Plaza-Midwood neighborhoods but unlike the
Louise Cotton Mill did not build company housing. (Courtesy of the Robinson-Spangler
Carolina Room, PLCMC.)

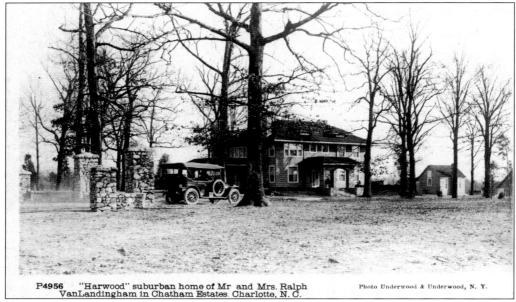

P4956 "Harwood" suburban home of Mr and Mrs. Ralph Photo Underwood & Underwood, N. Y.
VanLandingham in Chatham Estates. Charlotte, N. C.

Ralph Van Landingham's home is the largest in Plaza-Midwood. Ralph served as warden of Saint Peter's Episcopal Church, treasurer of the Charlotte Country Club, and vice president of the Plaza Railway Corporation. His wife Susie received President Wilson's commendation for running the Red Cross at Charlotte's Camp Green during World War I. Ralph Jr. willed the property to UNC-Charlotte, saving it from "redevelopment." (Courtesy of J. Murray Atkins Library Special Collections.)

With backing from James B. Duke (seen here), engineer William States Lee created Southern Power Company to serve Charlotte's growing industries. Edward Dilworth Latta, who ran Charlotte's streetcars, was squeezed out by the growing Southern Public Utilities division of Duke's company. Plaza-Midwood was the scene of a showdown involving the two rivals. Through hostile action, Duke's SPUC put Latta out of the streetcar business. Duke Energy Company became a household name in Charlotte and one of the largest public utilities worldwide. Along with banking, Duke's company fueled Charlotte's booming economy. (Courtesy of Duke Energy Archives.)

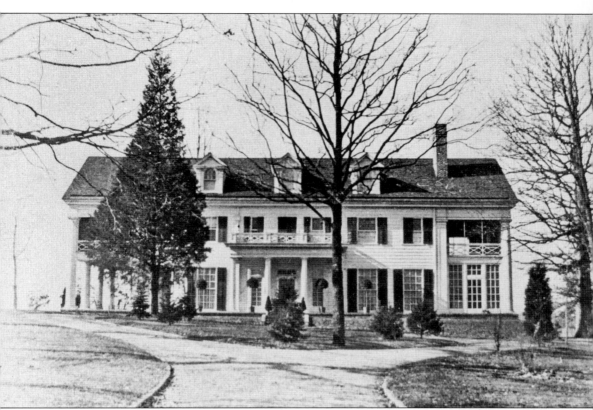

As testament to his position, Duke purchased this home on Hermitage Court in Myers Park in the 1920s, seen here in its original state. Duke had it remodeled to three times the original size and, like the Van Landinghams, chose architect C.C. Hook to design the additions. Tellingly, though he may have indirectly assisted Paul Chatham in his efforts to secure streetcar service from Latta, he did not choose to make his home in Chatham Estates on the Plaza. By the time Duke purchased the house, wealthy Charlotteans were beginning their migration southeast, confounding the aspirations of Chatham and later Plaza-Midwood developers. (Courtesy Robinson-Spangler Carolina Room, PLCMC.)

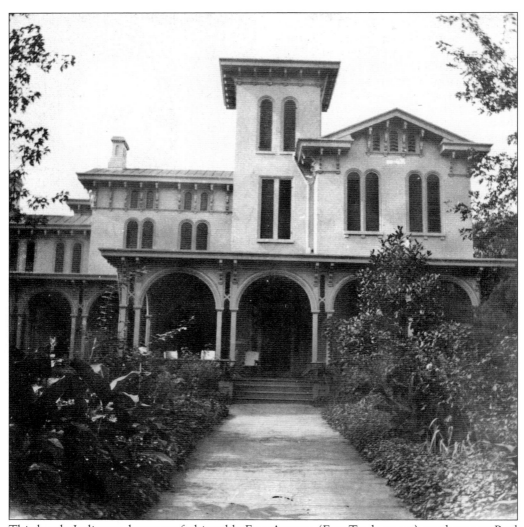

This lovely Italianate home on fashionable East Avenue (East Trade street) was home to Paul Chatham and his wife DeWitt. Taking up almost a whole city block, the home provided an impressive base of operations from which Chatham could attract other elite Charlotteans to his Plaza development. Chatham was born in 1869 to a prominent Elkin, North Carolina woolen mill family and attended Trinity University (Duke University). He moved to Charlotte in 1907 and served as president of the W.G. Ross Company and as secretary and treasurer of Piedmont Clothing. He purchased a large tract of land between Central Avenue and Parkwood east of Second and Fourth Wards. He remodeled a farmhouse that stood on present-day Thomas Street. Eventually he purchased much of what became the Chantilly neighborhood adjacent to Plaza-Midwood, but sales in both areas were slow. Crucial to Chatham was the establishment of streetcar service. Unlike Myers Park's George Stephens, Chatham was unwilling or unable to subsidize the expensive service and was rebuffed by Edward Latta. There is evidence that Chatham, a close associate of James B. Duke and William Lee, may have conspired to put Latta out of business. Chatham remained active in Charlotte business life until his death in 1944. (Courtesy of J. Murray Atkins Library Special Collections.)

The gentleman at the top is Charlotte mayor Tom Franklin, who paved Tryon Street and secured funds from the Carnegie Foundation to build Charlotte's first public library. Franklin was mayor during the conflict over streetcar service. The dapper gentlemen on the bottom are aldermen from Charlotte's four wards. It was before this body that Chatham and Latta publicly argued over trolley franchising. Rebuffed by Latta, Chatham came before the aldermen in 1910 to argue for a private streetcar franchise, a tactic used all over the nation against established streetcar utilities. Private franchises were awarded and transferred to larger firms seeking to squeeze out the established utility. Latta opposed Chatham's request for a private streetcar franchise to service the Plaza and Charlotte Country Club; he was unsuccessful, but the aldermen denied Chatham the right to transfer the franchise. Instead of turning the line over to an entity more capable of funding and improving it, Chatham was stuck with the operating costs. (Courtesy of the Robinson-Spangler Carolina Room, PLCMC.)

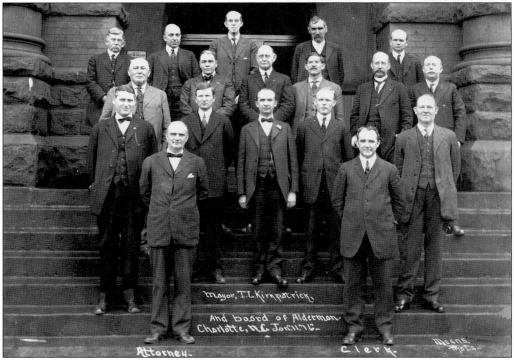

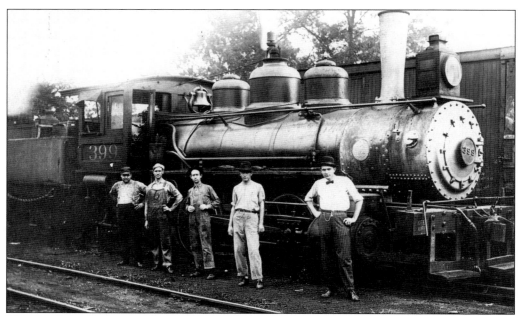

These railway workers posing in front of their engine *c.* 1900s were part of a service vital to Charlotte's growth, but railroad crossings spelled trouble for developers like Chatham seeking to attract homeowners to north and east Charlotte. Rail lines hemmed in the eastern side of the city until the 1930s, by which time Myers Park and Elizabeth had outpaced Plaza-Midwood. An overpass bridge at Elizabeth Avenue eased access to southeast Charlotte, while passengers on Central Avenue and Parkwood had to wait for lengthy and frequent locomotive traffic. Because of this wait, lots in Plaza-Midwood could not be sold at as high a price and more modest housing developed where Chatham envisioned his posh streetscape. The Southern Railway depot at the bottom served the most important rail links between Charlotte and the growing region. (Courtesy of Robinson-Spangler Carolina Room, PLCMC.)

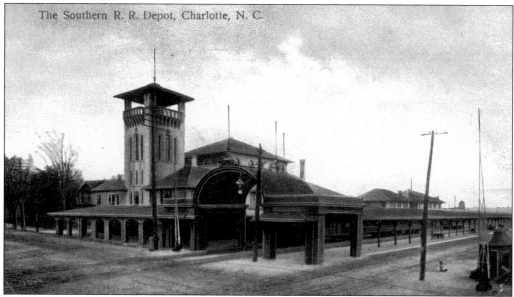

The Southern R. R. Depot, Charlotte, N. C.

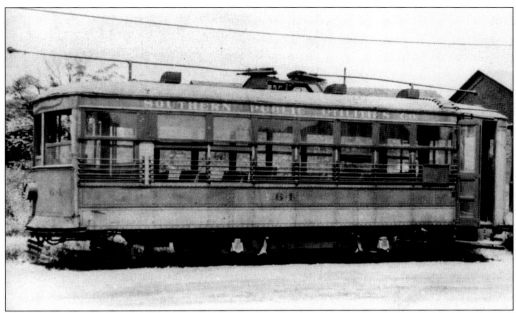

This is SPUC streetcar number #64 *c.* 1930. By the 1930s, Charlotteans were discovering their love for the automobile. The first automobile suburb in Charlotte had begun development in Eastover, adjacent to the old streetcar suburbs of Elizabeth and Myers Park. Charlotte's daily commute to the suburbs had begun. (Courtesy of Duke Energy Archives.)

This bill of sale from Southern Public Utilities Company to Plaza Railway signed January 18, 1922, involved the sale of one streetcar described as follows: "Painted in two colors; straw and light mahogany, numbered 'one' on sides and ends, and lettered 'Plaza Railway' on each side." It is signed by officials of SPUC and Plaza Railway vice president Ralph Van Landingham. (Courtesy of Duke Energy Archives.)

STATE OF NORTH CAROLINA,
COUNTY OF MECKLENBURG.

THIS BILL OF SALE, Made and entered into this 18th day of January, A. D. 1922 by and between SOUTHERN PUBLIC UTILITIES COMPANY, a corporation duly organized and existing under and by virtue of the laws of the State of Maine, Party of the first part, and PLAZA RAILWAY, INCORPORATED, a corporation duly organized and existing under and by virtue of the laws of the State of North Carolina, party of the second part, WITNESSETH:

THAT the party of the first part in consideration of the sum of Three Thousand Dollars ($3,000.00) to it paid by the party of the second part, the receipt of which is hereby acknowledged, has bargained and sold and by these presents does bargain, sell, convey, set over and deliver unto the said Plaza Railway, Incorporated, one street railway car, more particularly described as follows:

Painted in two colors, viz., straw and light mahogany, numbered 1 on sides and ends and lettered "Plaza Railway Company Incorporated" on each side; mounted on Lord Baltimore Single Track and equipped with two GE-52 motors and Westinghouse Air Brakes.

TO HAVE AND TO HOLD the said street railway car to the said Plaza Railway, Incorporated, its successors and assigns to its and their only use and behoof forever.

IN TESTIMONY WHEREOF, the said party of the first part has caused these presents to be signed in its name and behalf by its President, its corporate seal to be hereto affixed and to be

-1-

39

This c. 1918 trolley car resembles the cars of the Chatham line. Because of the conflict before the board of aldermen in 1910, Chatham had to operate a battery-powered line from the termination of the line at Hawthorne and Central, up Central, left onto the Plaza, and right on Mecklenburg to the end of the track near Club drive. Its trolley barn sat at the intersection of the Plaza and Parkwood. No images are known to exist of the barn, although longtime resident Charles Paty remembers the cars sitting idle in it until the tracks were removed in the late 1930s. (Courtesy of Duke Energy Archives.)

Trolley men pose in front of the Dilworth trolley barn c. 1920s. The small Plaza Railway had trouble with injuries, both job-related and personal-claim, as did all trolley lines. The line was plagued by small suits and past-due bills as well as back wages for trolley men. (Courtesy of Duke Energy Archives.)

The Oakhurst Land Company filed a lawsuit against Plaza Railway in July 8, 1931, stemming from the railway's inadequacy serving the area around Plaza-Midwood and the railway's debt to Oakhurst for a sum of $3,875.18. Past-due bills to Southern Public Utilities Corporation for $2,316.07 were also owed. The settlement relieved SPUC of liabilities and claims in exchange for $5,000 paid to Plaza Railway. James Duke finally obtained Paul Chatham's franchise, 20 years after the original conflict. (Courtesy of Duke Energy Archives.)

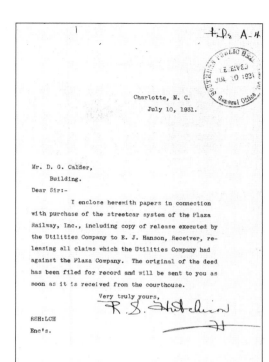

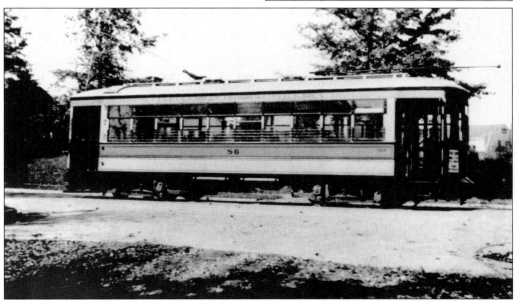

Cars like #86 in the SPUC line ran to all major suburbs in each direction. There were connections to railway lines dedicated to amusement parks such as Lakewood Park in west Charlotte and special trolley lines to Latta Park in Dilworth. A light-rail system connected the mill towns of Gastonia, Belmont, Mt. Holly, and Cramerton to the grid. There were lines running up Parkwood Avenue and from Central onto Hawthorne through the Belmont neighborhood near Plaza-Midwood. (Courtesy of Duke Energy Archives.)

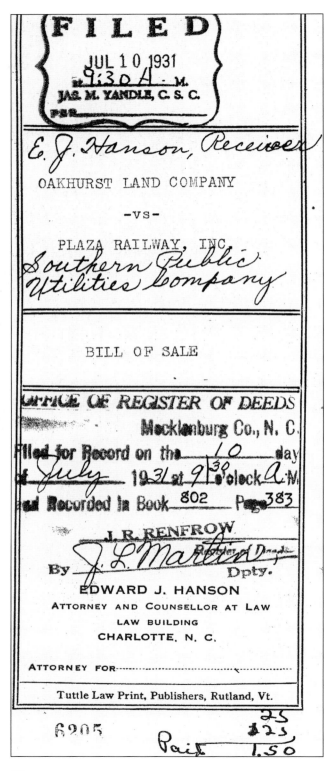

This paper work shows the final settlement of the lawsuit brought by the Oakhurst Land Company against the Plaza Railway Company. It is dated July 10, 1931. The filing cost for the lawsuit was $1.50. The judgment conferred all rights-of-way and franchises. (Courtesy of Duke Energy Archives.)

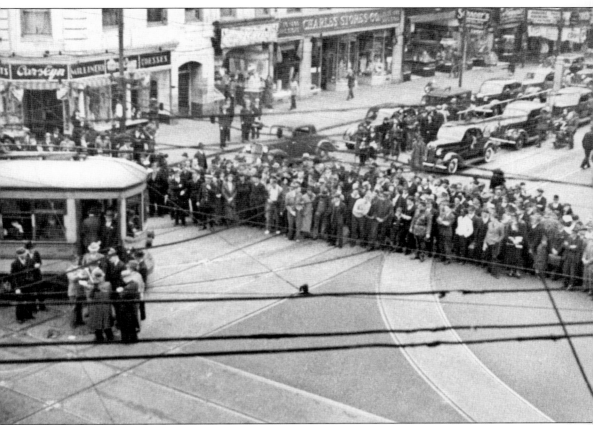

Here crowds line up to watch the last trolley run on Independence Square. Seven years after Plaza Railway's sale, Southern Power and Utilities Company discontinued streetcar service in 1938—a national trend as automobiles became more common. The consequences of increased automobile use would be felt in the following decades as new suburbs opened, causing many homes in Plaza-Midwood to sit empty or be converted to multifamily or business use. In the early 1980s, road improvements revealed the Plaza trolley tracks to residents, many of whom bought souvenir pieces through a fund-raiser for the neighborhood association. (Courtesy of the Robinson-Spangler Carolina Room, PLCMC.)

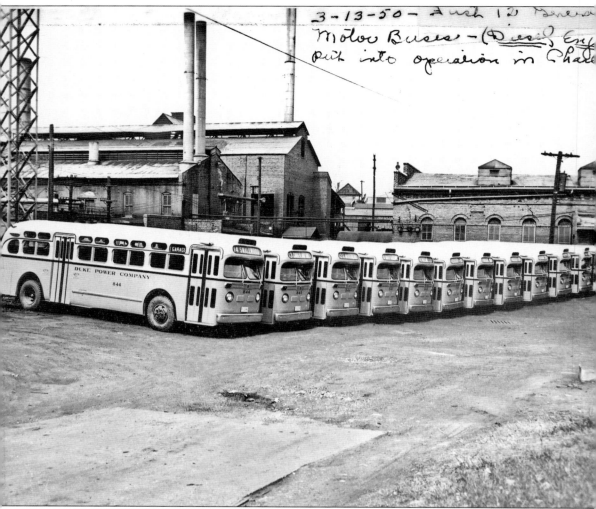

City buses are seen parked at the old trolley barn in Dilworth *c.* 1950. Rubber tires replaced trolley tracks, and by the time this photo was taken, mass transit in Charlotte was on the wane. Presently there is a move to restore the streetcar system in Charlotte as part of a light-rail system; much talk is being made about once more running a streetcar line down Central Avenue. (Courtesy of Duke Energy Archives.)

Three

MAJOR DEVELOPMENT
"A City of Homes"

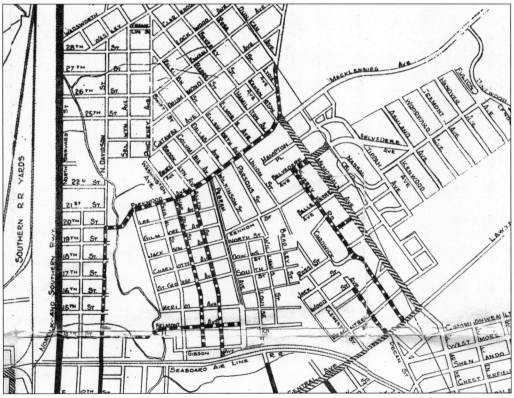

This 1921 Charlotte Chamber of Commerce survey map shows growth in Plaza-Midwood's vicinity—particularly in the "Midwood" section east of the Plaza—known then as "Memorial Avenue." Central Avenue was still referred to as "Lawyers Road" in the blocks after the Plaza intersection. Other streets were also named differently. Peachtree is now Hamorton. Nassau at the time referred to what is now the cul-de-sac of Thurmond Place, and Woodward is now Winter. (Courtesy of the Robinson-Spangler Carolina Room, PLCMC.)

THIS BEAUTIFUL BOULEVARD RUNS THROUGH THE CENTRE OF CHATHAM ESTATES AND CONNECTS THE COUNTRY CLUB WITH THE CITY. THIS PLAZA IS ONE HUNDRED FEET WIDE.

A CITY OF HOMES

JUST as Charlotte has taken leadership industrially, so has she taken social, political, civic and educational leadership. The red-blooded men who have cast their fortunes here realized that no town could succeed and be one-sided—just an industrial unit. They wanted Charlotte to be *Home* in every sense of the word. To this end all branches of Public Service, Sanitation, Health, Water Supply, Parks, Building Conditions, Clubs and Educational Institutions, have received hearty and systematized support.

¶ The result has justified these civic efforts. The U. S. Census shows that a larger percentage of Charlotte's population owns homes than in any other city of its size. To thinking men, this spells prosperity among the rank and file of the people who live here.

¶ Wide home sites are the rule and all the streets have these features, which add so much to their beauty and healthfulness.

¶ One of the most distinctive features of Charlotte is the beautiful suburban development in which special attention is given to park areas, community centers and building restrictions, which make a high standard of ideals as well as values.

¶ *Your Standing in the community is much higher and more permanent, when your friends and associates know that your money is invested in good real estate.*

This "City of Homes" promotional brochure dated 1914 showing the Plaza streetcar line and Bishop John Kilgo's home entices the potential buyer to "join with the other red-blooded men" who were "taking advantage" of opportunities a booming economy offered. The pamphlet uses the idea that home-ownership improves social standing. Charlotte at the time had the highest per-capita home ownership of any city its size. The brochure notes proximity to the Charlotte Country Club. It promises spacious lots for "healthful living," complete with parks and recreation centers. It promises that at no time on the trip from town to Chatham Estates, whether by automobile or streetcar, would the buyer have to travel through "any section inhabited by people of the Negro Race." For years, according to Dr. Tom Hanchett's *Sorting out the New South City*, Charlotte's wards were segregated, not by law but by custom. Fourth Ward was predominately white, as was Third. First Ward had overlapping white and black areas, and Second Ward—the section known as "Brooklyn"—was traditionally African-American. That such racist language was so common is indicative of the nation's climate at the time. This was the era of the Ku Klux Klan's greatest power, when white moviegoers thrilled to the mythic Reconstruction portrayed in D.W. Griffith's *Birth of a Nation*. Ironically the very areas adjacent to Plaza-Midwood mentioned in the text are now almost entirely African-American. East of the Historic District on both sides of the Plaza, the old Chatham Estates, Midwood, and Club Acres developments remained predominately white. (Courtesy of J. Murray Atkins Library Special Collections.)

This home at 1208 Clement Avenue is indicative of the modest homes built in Oakhurst, now part of the Plaza-Midwood historic district. These houses, adjacent to the area of the Hawthorne industrial corridor, represent working-class housing not built by "the company." Proximity to the Hawthorne factories made these lots appropriate to people who were in the working ranks of the New-South economy. Both the older neighborhood of Belmont and the Plaza-Midwood historic district are partially made up of homes similar to these. (Courtesy of Rich Snyder.)

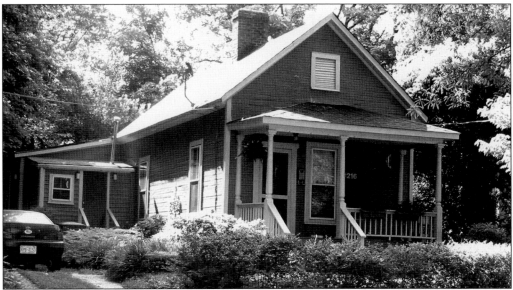

Shotgun houses like this one are noted for their front-to-back hallway and are more common in African-American and cotton-mill communities. This home at 1216 Clement Avenue was part of neither. The home was built for a machinist and is the neighbor of 1208 Clement and other modest blue-collar homes in the old Oakhurst and Belmont communities. (Courtesy of Rich Snyder.)

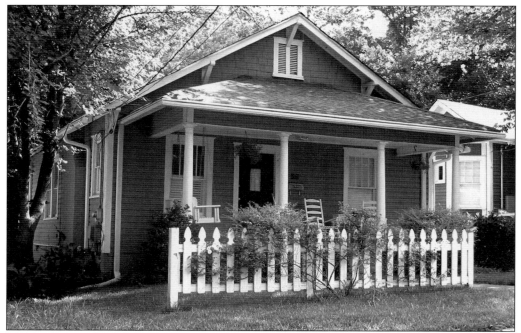

The roofline of this bungalow-style home is reminiscent of the larger versions across the Plaza, particularly on Belvedere Avenue. The scale of this house is another illustration of the fact that Plaza-Midwood's historic district was originally developed for mostly working-class or lower middle-class families in the old Oakhurst section. (Courtesy of Rich Snyder.)

Painter Vitchell Stroupe lived in this double-gabled late Victorian home at 1443 Pecan. It is another example of the less elaborate "workman's cottage" of the later Victorian era. (Courtesy of Rich Snyder.)

This modest home shows evidence of the California craftsman style that would become more popular in later developments east of the Plaza. The style would reach its peak in Plaza-Midwood with the design of Harwood, the Van Landingham family's grand estate on the corner of the Plaza and Belvedere. (Courtesy of Rich Snyder.)

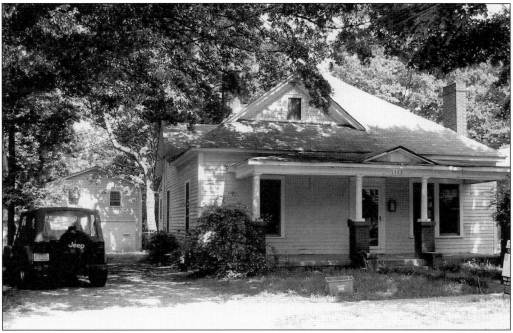

It is not known whether he worked for the Chatham or Southern Public Utilities Line, but trolley conductor Charles Wooten occupied this house c. 1910. (Courtesy of Rich Snyder.)

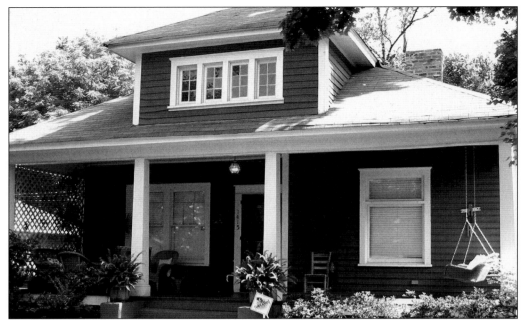

This home on Thomas Avenue shows a transitional bungalow style that began to show up in Plaza-Midwood's Oakhurst section in the wake of elaborate Victorian decoration. Taste was not the only factor in determining style. In the Age of the Machine at the end of the 19th century, craftsmanship was increasingly expensive. People of modest means would naturally gravitate to the more sober style of this bungalow, with its machine-turned wood and lack of decoration. (Courtesy of Rich Snyder.)

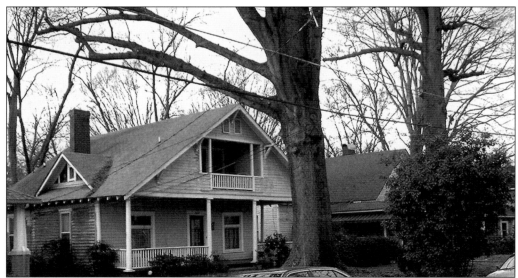

Now standing at 1409 Pecan, this home was built in 1910 for Arthur Helms. Helms was an assistant superintendent at Cole Manufacturing on Central Avenue. The home is notable for its upper-story inset balcony. The Helms family represented an example of a middle-class family living in an area dominated by the more modest homes of workers. (Courtesy of Rich Snyder.)

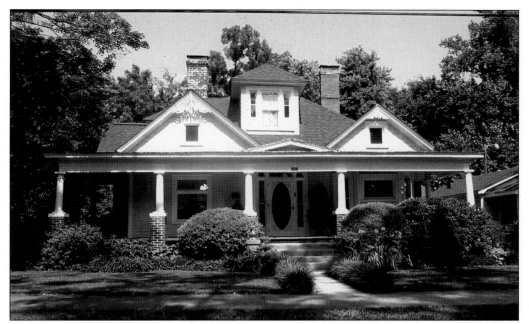

Casket-maker Jackson Kiser built this 1903 Victorian, one of the first residences in the Oakhurst section of Plaza-Midwood. Its elaborate gingerbread woodwork is a throwback to the heyday of Victorian over-embellishment. (Courtesy of Rich Snyder.)

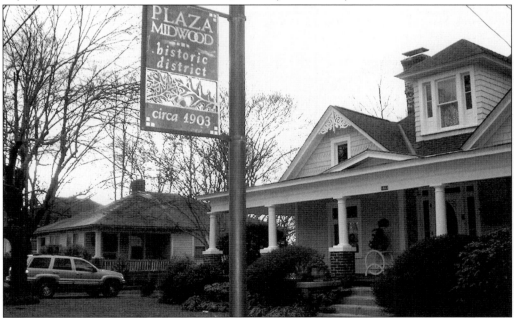

This view of casket maker Jackson Kiser's 1903 Victorian at 1409 Pecan Avenue shows the sign designating the Plaza-Midwood historic district, which runs from Thomas and Pecan across the Plaza from Hamorton to Belvedere. Some neighbors are still pushing to have the entire neighborhood from Pecan to the Country Club designated as historic. (Courtesy of Rich Snyder.)

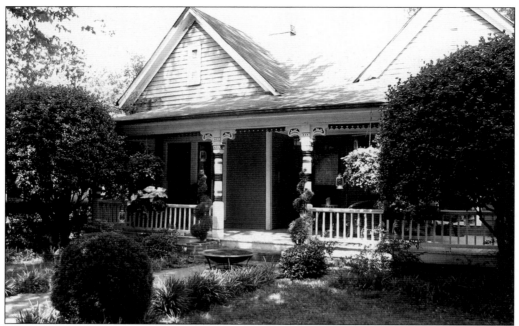

This early-1900s cottage at 1331 Thomas Avenue also shows the elaborate gingerbread woodwork of the late Victorian period, albeit on a more modest scale than the Kiser house. (Courtesy of Rich Snyder.)

Here is a prime example of the diverse architecture in Plaza-Midwood. At the left of the picture is a Spanish colonial-revival home built in the early 1920s, alongside a craftsman-style bungalow more typical to the neighborhood's streetscape. The homes are on the 1600 block of Thomas Avenue. (Courtesy of Rich Snyder.)

Quadplexes are common in all streetcar suburbs of Charlotte, especially in Dilworth, Elizabeth, and Plaza-Midwood. This two up–two down unit stands at 1600 Thomas Street and represents Charlotte's early need for multifamily housing. (Courtesy of Garrett Ladue.)

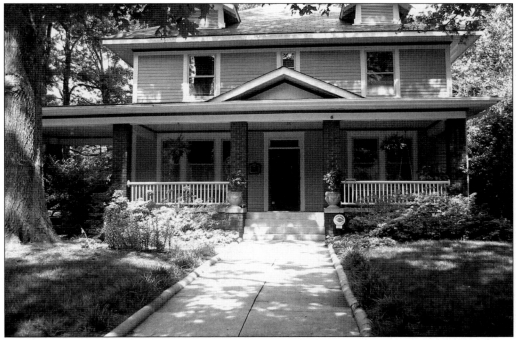

This home was built in 1916 for Charlotte auto-dealer J.D. Woodside. Woodside represented the kind of wealthy buyer courted by Paul Chatham. Woodside in fact was one of Chatham's last big customers. Distance from uptown and commuting issues, along with more pastoral lots in south Charlotte, dried up Chatham's pool of offers. To keep the Chatham Estates project going and ensure his cash flow, Chatham was forced to subdivide lots and allow smaller, less expensive homes to go up between more "stately" ones. (Courtesy of Rich Snyder.)

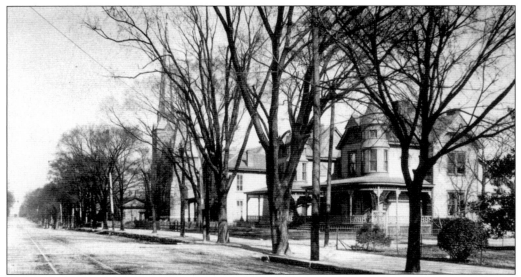

This 1890s photograph shows "Victoria" on its original site at the corner of Tryon and 7th Streets, downtown Charlotte, originally one of the two identical homes built for the sones of R.M. Miller—a textile investor. Present owners Bill and Fran Gay restored the home over many years. It is now on the National Register of Historic Places. Shortly after purchase in 1970, the Gays had a visit from an older woman who had watched the homes progress down Central Avenue by mule train in 1915 to its lot in Paul Chatham's development. (Courtesy of Bill and Fran Gay.)

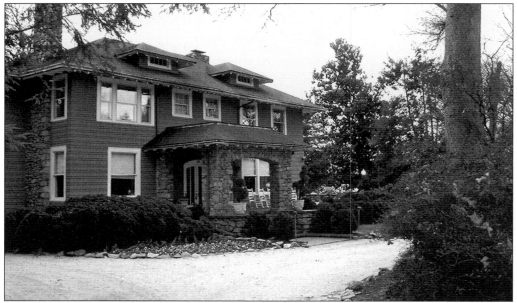

Plaza-Midwood people refer to this home as "The Van Landingham." Formerly known as Harwood, the home was designed by the firm of Hook and Rogers. It represents the Arts-and-Crafts bungalow style on a grand scale. Satellite buildings in the Arts-and-Crafts style have been added, and lush gardens make the Van Landingham estate an architectural anchor for Plaza-Midwood. (Courtesy of Garrett Ladue.)

This deed to Harwood, signed by John Van Landingham and Paul Chatham, is dated 1914. Two restrictions on this deed tell us much about the rural state of Charlotte. There is a restriction against raising pigs on the property—families in Charlotte both in high-end neighborhoods and on the "mill hill" supplemented their diet and kept to familiar rural ways by maintaining gardens, fruit trees, and even livestock. Another rider insists that the property convey only "people of the white race." (Courtesy of the Robinson-Spangler Carolina Room, PLCMC.)

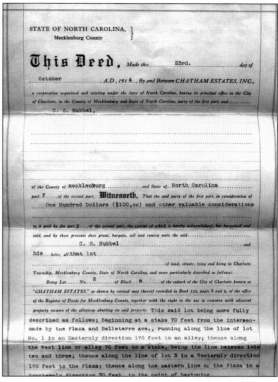

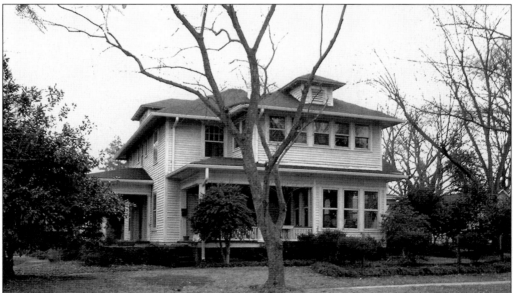

The Kilgo house at 2100 the Plaza was designed by Louis Asbury in the rectilinear style. Bishop John Kilgo, a native of South Carolina, was chancellor of Trinity College (Duke University) from 1894 to 1910. Kilgo tripled the number of students and faculty at Trinity and organized a women's college with its own dormitory on campus. He was the first Southern leader to invite Booker T. Washington to speak before a white audience. (Courtesy of Garrett Ladue.)

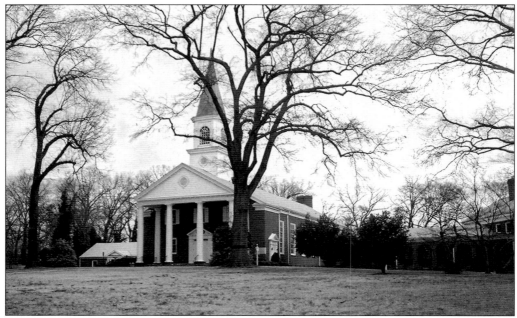

Kilgo United Methodist Church, seen here, was founded in the 1940s in honor of Bishop Kilgo. Originally the church met in a private home, which was used as a sanctuary until torn down to build the structure seen here. The church is active in community affairs, hosting neighborhood organization meetings and district voting location. (Courtesy of Garrett Ladue.)

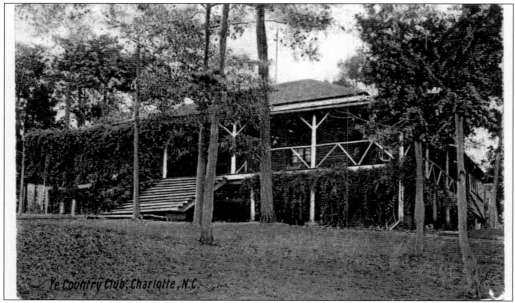

The structure in this early 1900s photograph is the original Charlotte Country Club, but it was never connected to the present club. It was located near a lake off Mount Holly Road and has long-since vanished. It was necessary to keep a motorbus and two carriages at the ready to transport club members to its functions held so far out of town. (Courtesy of the Robinson-Spangler Carolina Room, PLCMC.)

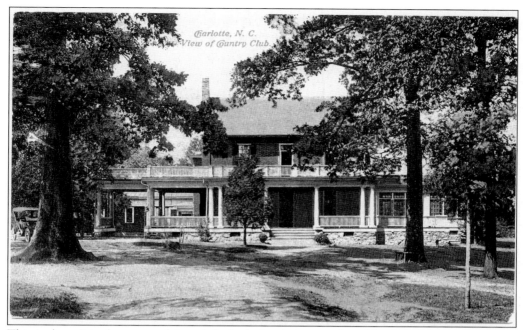

This is the original country club as it looked after being purchased by the club's stockholders, who included construction tycoon and future WBT Radio owner F.M. Laxton, textile magnate Stuart Cramer, and Southern Power and Utilities head man W.S. Lee. (Courtesy of the Robinson-Spangler Carolina Room, PLCMC.)

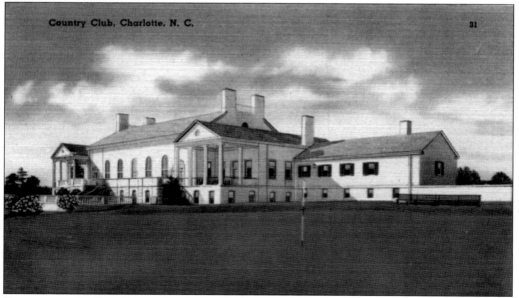

Princeton-trained architect Aymar Embury designed the structure in a neoclassical style popular with conservative club members. His designs were as diverse as the Maidstone Country Club in East Hampton, New York, and the Triborough Bridge and Lincoln Tunnel to the New York Building at the 1939 World's Fair. (Courtesy of the Robinson-Spangler Carolina Room, PLCMC.)

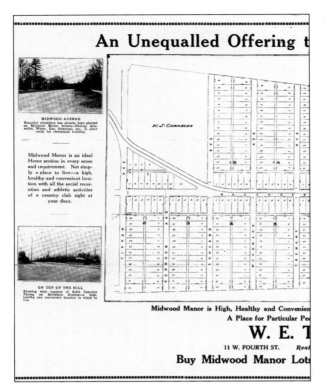

An Unequalled Offering t

MIDWOOD AVENUE
Beautiful shrubbery has already been planted on Midwood Manor streets—Paving, sidewalks, Water, Gas, Sewerage, etc., in place ready for immediate building.

Midwood Manor is an ideal Home section in every sense and requirement. Not simply a place to live—a high, healthy and convenient location with all the social recreation and athletic activities of a country club right at your door.

ON TOP OF THE HILL
Showing wide expanse of Solid Concrete Paving on Belvedere Avenue—a high, healthy and convenient location in which to live.

Midwood Manor is High, Healthy and Convenien
A Place for Particular Peo

W. E. T

11 W. FOURTH ST. Real

Buy Midwood Manor Lot

The last major development in Plaza-Midwood was first proposed in the early 1920s. This brochure, distributed by W.E. Thomas Real Estate c. 1922, indicates the desire so elusive to Paul Chatham—an exclusive residential area for the well heeled. Along this main thoroughfare, originally fitted with trolley wiring and trenches for tracks, were the wide lawns of grand estates. In deference to changing times and the availability of automobiles among the well to do, the tracks were never completed. (Courtesy Charles Paty.)

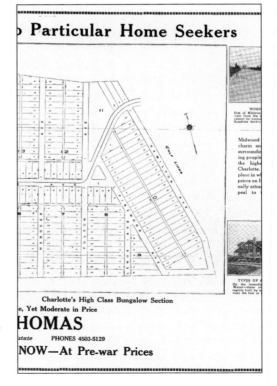

Particular Home Seekers

Charlotte's High Class Bungalow Section
e, Yet Moderate in Price

HOMAS

state PHONES 4503-5129

NOW—At Pre-war Prices

This section of the flyer references the eastern end of Midwood Manor, adjacent to the golf links of the Charlotte Country Club. The bottom photo in the brochure is today's 1801 Belvedere Avenue, at the corner of Thurmond and Belvedere near the rear of the van Landingham estate. The first block of Belvedere east of the Plaza is seen under construction. (Courtesy Charles Paty.)

In the final section of the Midwood Manor brochure, the Thomas company offers "Your City Home and Country Club Combined." The top picture inset depicts Belvedere Avenue with no homes on either side. Note the trolley-line poles in preparation for wire to be strung. Neither the wires nor the trolley arrived, and the rail trench was covered over. Charles Paty recalls the ridges they left in the street. (Courtesy Charles Paty.)

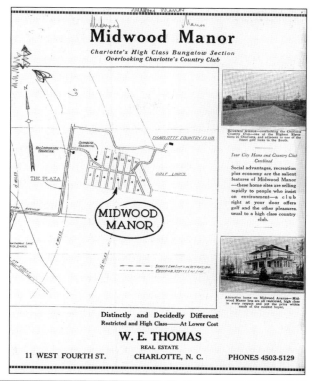

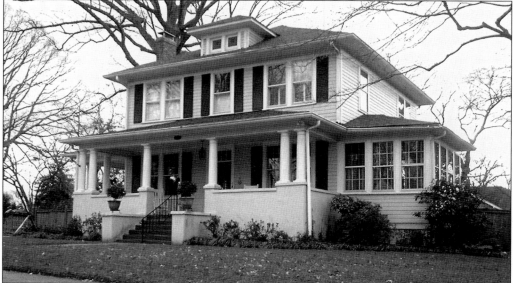

Here is a current picture of the home appearing in the lower-left corner of the brochure, one of the most architecturally impressive homes in the Midwood section. Most of the homes in this section are smaller craftsman bungalows. Echoing the development of Chatham Estates, early buyers tended to be wealthier and built larger homes. But again, distance from uptown could not be compensated for by the presence of the Charlotte Country Club. (Courtesy of Garrett Ladue.)

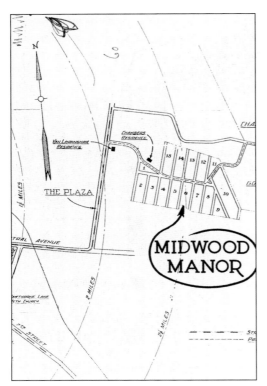

This close-up section of Midwood Manor shows lots on Midwood, Belvedere, Ashland, and other streets familiar to present Plaza-Midwood residences. It shows those areas on the eastern side of the Plaza that had been part of the Chatham Estates as well. Both areas lay just about two miles outside from the uptown area. (Courtesy of Charles Paty.)

This portion of the Midwood Manor brochure shows the correlation of the neighborhood to the tracks of the Plaza Railway Company streetcar line. The Thomas group may have made a mistake in doing so, as neither track was considerably close or convenient at the time. (Courtesy of Charles Paty.)

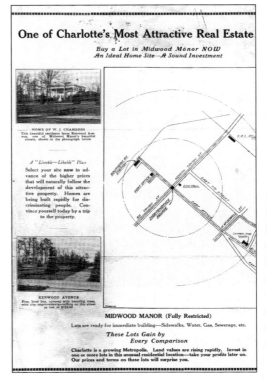

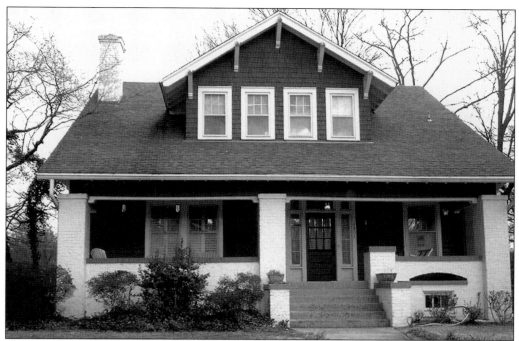

A classic Midwood bungalow of the 1920s is pictured at 1801 Belvedere. Midwood's developers were more successful in attracting wealthy and upper middle-class homeowners, but lots were subdivided, and homes of differing styles and decades were built, giving the section architectural variety. Between the 1920s and 1930s bungalows and colonial revivals, the cottages of the 1940s and 1950s were built, and even some of the ranch styles that would come to dominate subdivisions further east appear. (Courtesy of Garrett Ladue.)

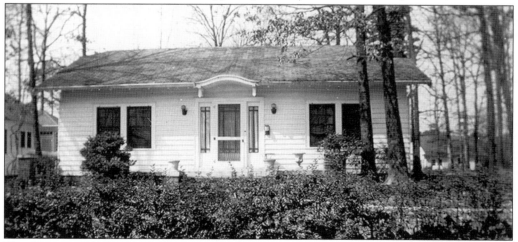

The house at 1927 Kenwood Avenue, *c.* 1943, was the boyhood home of Plaza-Midwood's unofficial historian, Charles Paty, and subject of much of his *Bull Frogs and Arched Doorways* collection of Midwood stories. Mr. Paty recalls how lots were subdivided and granite curbs laid on unpaved streets through out the Midwood section. Midwood Manor and its adjacent smaller developments such as Forest Circle would not completely infill until the common ownership of automobiles. (Courtesy of Charles Paty.)

The homes pictured in this 1929 photo are unidentifiable today but were listed in the 1300 block of Nassau Boulevard, which may have actually been part of Thurmond Place today. Chatham's landscape designer Leigh Colyer conceived Nassau as a loop road surrounding a park along the stream running from the Van Landingham estate through the area behind Tippah. The house in the foreground belonged to Jonathan Sellers, a vice president with Central Lumber Company, and his wife Grace. Optician Rupert Harris and his wife Virginia resided at 1304 Nassau. (Courtesy of Charles Paty.)

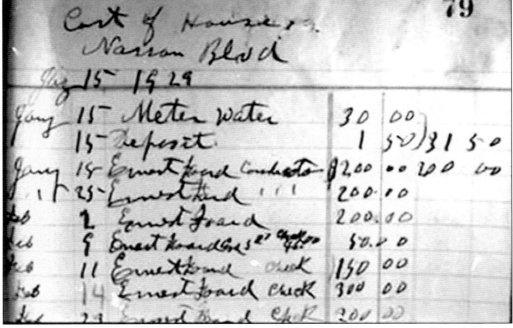

Here we are able to glimpse into the cost of home building in the Nassau Heights subdivision c. 1929. Included in the figures are the water meter, deposit, and hardware. The date on the document is August 15, 1929. (Courtesy of Charles Paty.)

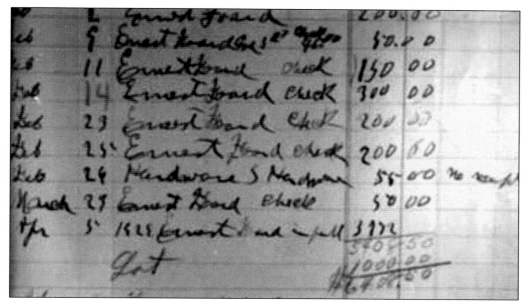

Added construction costs and fees bring the total cost including the lot to just over $6,500. These figures seem low by today's standards, but at a time when an average factory worker was lucky to make $15 per week, one can understand the sacrifices made for home ownership. (Courtesy of Charles Paty.)

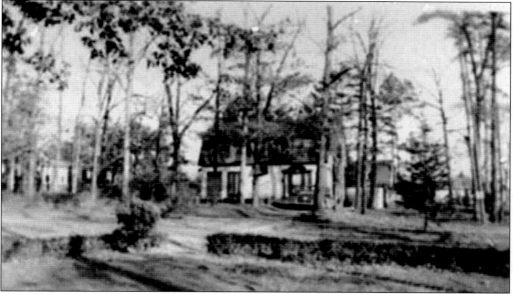

Seen here c. 1943 is the Dutch colonial style McMullen home built in the late 1920s at 2000 Kenwood Avenue. Local residents remember utility trucks spraying oil on the roads to prevent dust. Pearl Sanger, a longtime resident of Midwood, recalled the mess made by the oily feet of children, especially in summer. The current owner of this house is a descendant of Tom Franklin, Charlotte's mayor during the Chatham-Latta struggle over streetcar franchises. The original owner, Walter McMullen, was a sales manager with Scott Buick on West Trade uptown, and his wife Isabel was a stenographer. (Courtesy of Charles Paty.)

This street scene shows varying styles at the confluence of Belvedere, Chambwood, and Midwood. This type of infill was based strictly on market demand and, as all over Midwood, occurred through a span of some 30 years. Although this area represents some of the oldest houses in the Midwood subdivision, probably because of it proximity to the streetcars of the Plaza Railway, this section of Midwood would not fill in totally until the 1950s. (Courtesy of Garrett Ladue.)

This classic Midwood bungalow was built in the 1920s. It is typical of the majority of homes in the section. Active community organizations such as the Neighborhood Watch and the Plaza Midwood Neighborhood Association draw new residents as much as increasing return on investment. New homebuilders are now engineering communities with a neighborhood feel and "Midwood-style" bungalows in an effort to attract buyers. Plaza-Midwood's sense of community, however, is as authentic as its architecture. (Courtesy of Garrett Ladue.)

This brick bungalow on Kensington drive is the home of former Plaza-Midwood Neighborhood Association president Garrett Ladue. The home's deed states that it lies within Chatham Estates. It is adjacent to the larger bungalows of Nassau Heights in the vicinity of Hamorton Drive. Nassau Heights developers included Charlotte real-estate speculators U.S. Goode, F.E. Robinson, and T.D. Newell, who purchased the plots from Paul Chatham. (Courtesy of Garrett Ladue.)

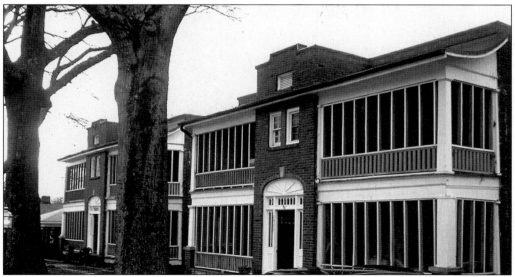

Like the quadplex on Thomas Avenue, this building on Club Drive satisfied the need for rental housing during the early development of Plaza-Midwood. Located on one of the most architecturally diverse streets in Plaza-Midwood, the apartments have been converted into condominiums. (Courtesy of Garrett Ladue.)

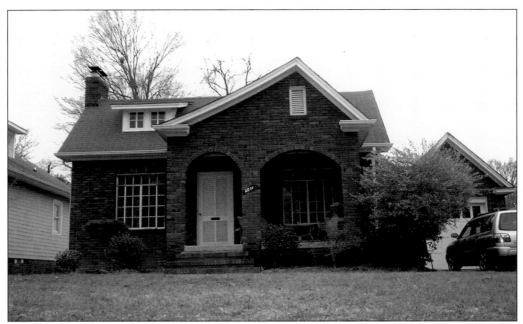

Club Drive, off Central Avenue, was originally planned in 1925 by a group of Charlotte attorneys. Originally, the street was to have been called Ridgeway Avenue. Like all sections of Plaza-Midwood, its architecture is as diverse as the people who inhabit the neighborhood. The one-story bungalow is on Club Drive. (Courtesy of Garrett Ladue.)

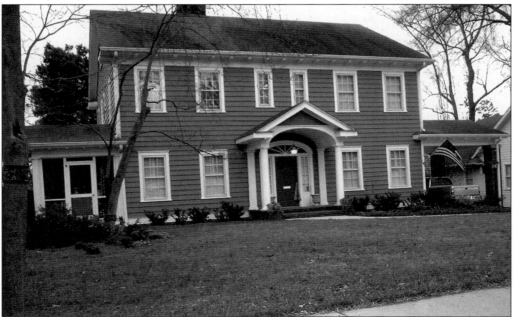

The large colonial revival seen here is on Truman Avenue in the section developed as the Eastern Retreat neighborhood in the 1940s. Beyond Truman Avenue, the area was developed as Masonic Drive, which lay adjacent to the Charlotte Country Club's golf links. It did not fill in totally until the 1950s. (Courtesy of Garrett Ladue.)

Four
CENTRAL AVENUE
Charlotte's "Miracle Mile"

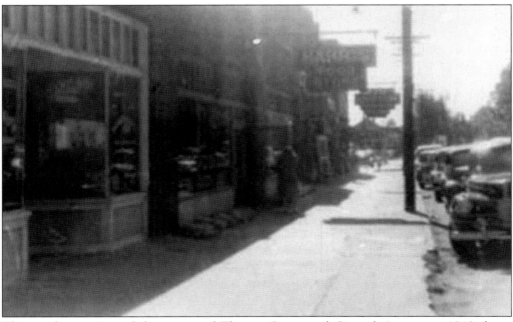

This southwest view of the corner of Thomas Street and Central Avenue c. 1940 shows the location of the Plaza Coffee Shop and Harris Food Store. Framing the scene is the sign of one of many service stations along the miracle mile—in this case Esso brand. (Courtesy of Charles Paty.)

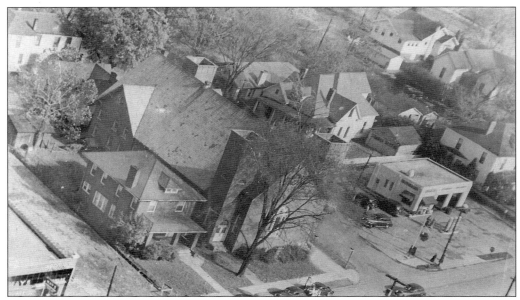

In this 1930s aerial view of Central Avenue at Pecan, one can see the original Holy Trinity Lutheran Church near the corner of Pecan and Central. To its immediate left is the parsonage, the only remaining structure on this block, now in use as a real-estate office. Behind the site is part of the Plaza-Midwood neighborhood on the edge of Oakhurst. Most of these cottages did not survive their role as boarding houses prior to re-zoning in the 1970s and 1980s. (Courtesy of Holy Trinity Lutheran Church.)

In the upper right of this view of Pecan and Central c. 1944 is the first commercial building in Central Avenue's original streetcar strip. Originally occupied by Long's Grocery, the building was constructed in 1916. At the date of this photo, it was occupied by the Armstrong Grocers and the block had filled in with other commercial buildings. (Courtesy of Charles Paty.)

W.T Harris launched his Harris-Teeter food store chain in this modest Central Avenue location, seen here *c.* 1941. Local residents remember Mr. Harris bagging his own groceries and waiting on customers. From these humble beginnings Harris eventually moved to a modern supermarket in the late 1940s, still located on the corner of the Plaza and Central Avenue. W.T. Harris Boulevard, his namesake, is a major highway through the University area of north Charlotte. (Courtesy of Charles Paty.)

The lady crossing the corner of Pecan and Central in this 1941 photo may have just eaten lunch at the Plaza Coffee Shop or placed an order at the Harris food store. Over her shoulder is the sign for the Esso gas station. Plaza-Midwood residents depended on small local businesses until the development of shopping malls like Midtown Square. (Courtesy of Charles Paty.)

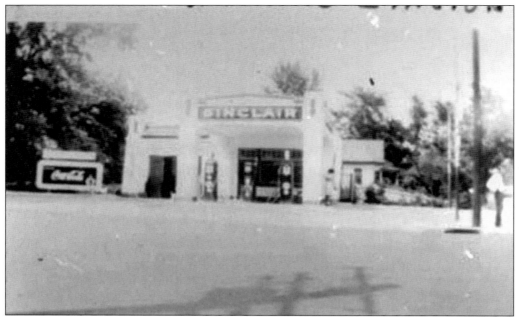

This Sinclair filling station c. 1941 at the corner of the Plaza and Central was one of many filling stations in the Plaza-Midwood business district. It served as an early convenience store where kids from Central High or Midwood Elementary could buy candy or Cokes. Behind it can be seen homes demolished to make way for the Midwood Branch of the Charlotte Mecklenburg Library in the late 1990s. (Courtesy of Charles Paty.)

"One on every corner" is how locals describe the abundance of filling stations in the Plaza-Central business district. This photo of the Dewese Gulf Station on Central Avenue is important in that it shows the residential nature of the block before commercial structures replaced homes in the 1950s and 1960s. (Courtesy of Charles Paty.)

Automobiles like this one seen in this 1940s photo at the intersection of Pecan and Commonwealth would soon cause the decline of retail business in the Plaza-Central business district. This row of businesses was home to Plaza Drug Store and the original A&P Grocery Store. (Courtesy of Charles Paty.)

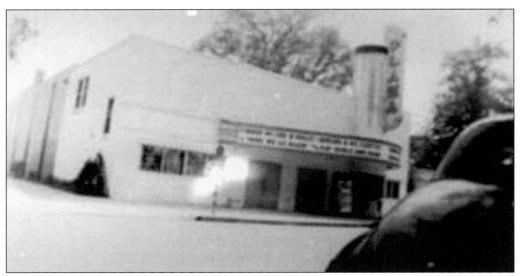

The Plaza Theater is a gem lost to both urban decay and "progress." Here the 1941 marquee features Fibber Magee and Molly and Charlie McCarthy. The Plaza was one of many neighborhood theaters, like the Visualite in Elizabeth and the Carolina Theater downtown. The Plaza, built by noted Charlotte architect M.R. Marsh, was a fixture in the community. Unfortunately, it was a casualty of neighborhood decline. Former Plaza resident Perrin Henderson fondly recalls leaving his bike and brittany spaniel, "Pup-pup," in front of the Plaza to find both where he left them at the movie's end. (Courtesy of Charles Paty.)

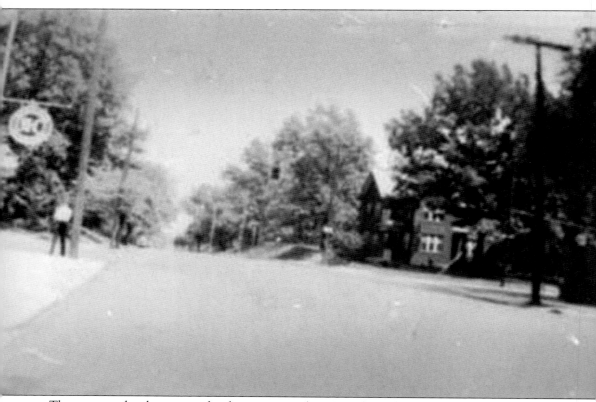

The streetcar has been gone for three years in this 1941 photo, looking north down the plaza, but one can still imagine the tracks heading toward Parkwood and Mecklenburg. This was the gateway to the various neighborhoods where developers like Paul Chatham tried to fulfill their dreams, and where families of great or modest means would make their homes. They would gather at churches, socialize, work, and face the Great Depression and all our nation's modern wars. They would watch their neighborhood teeter on the verge of ruin and through their efforts make its way back. (Courtesy of Charles Paty.)

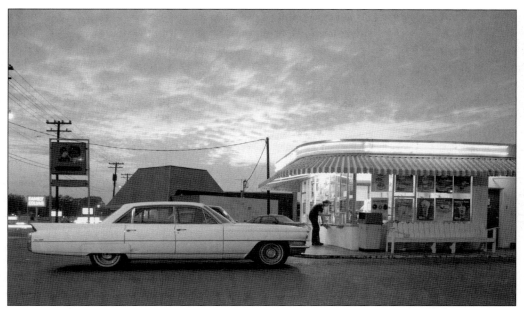

Charlotte photographer Byron Baldwin took the following nine photos in 1989, just as Plaza-Midwood and its business district began emerging from a long period of decline. These images capture many long-gone businesses and some still going strong. Some remain favorite Plaza places. Others were sources of concern during the neighborhood's "at-risk" years. These images capture the dignity of a resurgent neighborhood. Here Baldwin captured a favorite summer destination for Plaza-Midwood folks: the Dairy Queen. Built in 1950 in the Art Moderne style, the structure is a classic design for the age of the automobile. It is designated an historic landmark. (Courtesy of Byron Baldwin.)

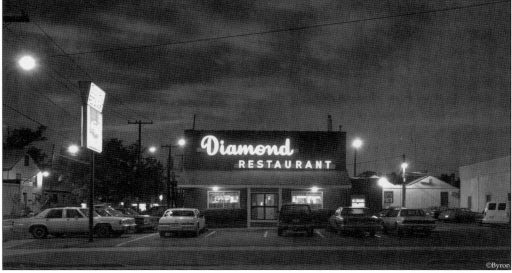

The Diamond is a favorite diner in the Pecan-Commonwealth block of the business district. It opened in 1945 and still sports a neon sign that lets you know you're entering Plaza-Midwood. The Diamond continues to attract a mixture of old-time customers and new faces looking for comfort food and sweet tea. (Courtesy of Byron Baldwin.)

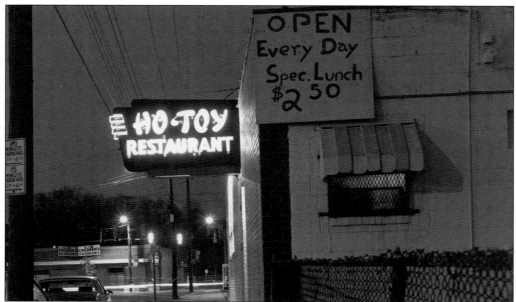

In this photo, the neon sign of the old Ho Toy Chinese Restaurant still glows. Until the 1980s and 1990s, Charlotte had only a few Chinese restaurants. Many older residents recall eating Ho Toy as a special event. Interestingly, the building was attached to the 1880s farmhouse Paul Chatham renovated and occupied while he developed his properties. The house, like so many other residences in the business district, was demolished to make way for commercial space. (Courtesy of Byron Baldwin.)

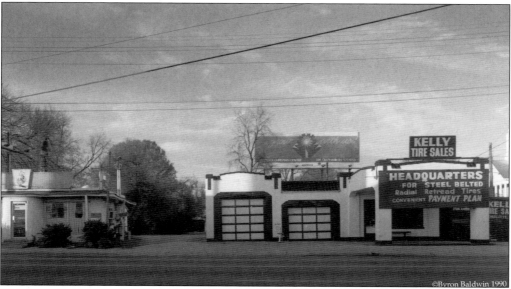

This was the former Sinclair station that, at the time of this photo in 1989, was known as Kelly's Tires. Beside it on the left is the All American Diner, owned by Greek immigrants like so many of Charlotte's landmark diners and coffee shop restaurants. Both structures were razed to make way for the Midwood Branch of the Charlotte Mecklenburg Library. (Courtesy of Byron Baldwin.)

74

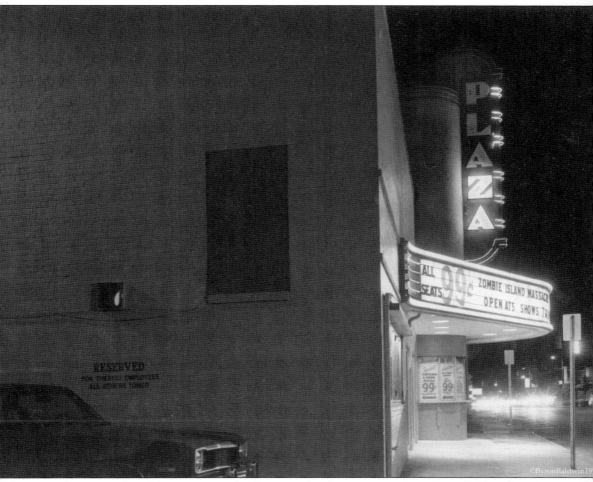

Here the old Plaza Theater's neon sign shines in the theater's incarnation as a horror theater. In previous years it had been an X-rated movie theater, which added to the "seedy" reputation developing around Plaza-Midwood in the 1970s and 1980s. (Courtesy of Byron Baldwin.)

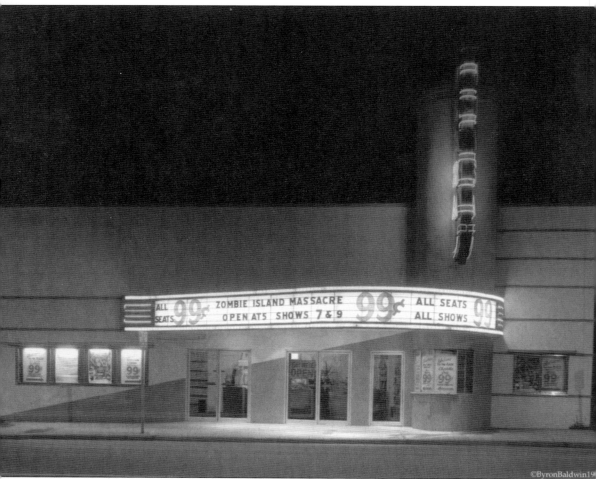

"Zombie Island Massacre" has replaced Charlie McCarthy on the Plaza's marquee. Local residents watched as the theater, like much of the neighborhood, fell into disrepair, becoming something of an eyesore. Unfortunately, the theater was destroyed in the 1990s to make way for a First Union bank branch. That structure is now vacant and may face the same fate as the landmark it replaced. (Courtesy of Byron Baldwin.)

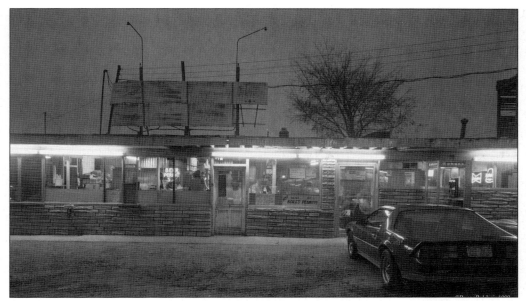

This image of the Penguin Restaurant was taken 11 years before renovation. Built in 1954 on the corner of Commonwealth and the Plaza, it was originally a drive-in; the Penguin was a favorite hang-out for high school kids according to longtime Midwood residents. It went through rough times in the 1970s and 1980s, when derelicts were commonplace up and down the Plaza and Central. But just like the neighborhood, the Penguin is back as part of major renovation in 2001 and continues to be a local favorite. (Courtesy of Byron Baldwin.)

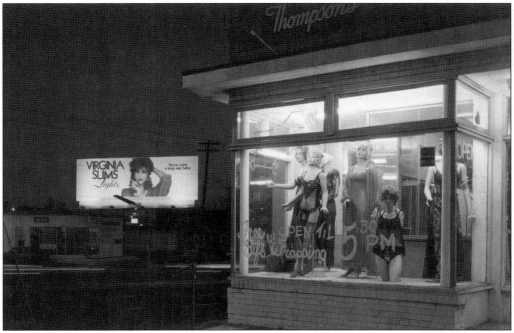

The Bootery and Bloomery, seen here, ironically sold children's shoes and lingerie, and its garish window displays are said to have caused fender benders by rubbernecking commuters.

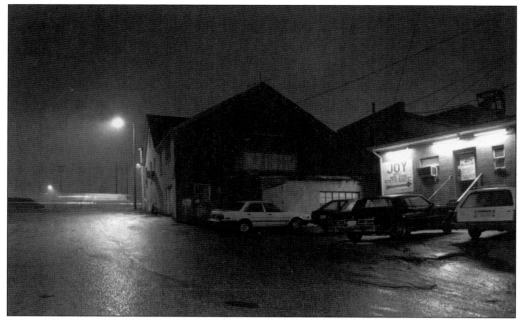

Behind the Bootery and Bloomery was the Joy Adult Bookstore seen here in all its seedy glory. The bookstore was one of many X-rated businesses that, according to longtime residents, encouraged prostitution—both female and male—for which the Plaza gained an unfortunate reputation. (Courtesy of Byron Baldwin.)

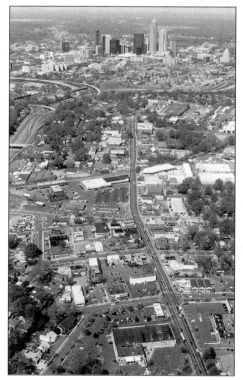

Compare this aerial view of Central Avenue to the 1921 Chamber of Commerce map in Chapter Three. It illustrates the difficulty Plaza-Midwood developers faced in locating their developments in a time when draught animals and feet had barely been replaced by streetcars. Manufacturing, retail, and real-estate development would grow up along Central Avenue—Charlotte's version of the "Miracle Mile." (Courtesy of Garrett Ladue.)

This row of buildings is opposite the old Long's Grocery on the northeast corner of Pecan and Central. In this block of commercial buildings, Leon Levine took over a failing five-and-dime store and launched his Family Dollar chain in 1959. Levine also began his Pic-n-Pay shoe store chain on Central Avenue. In the 1970s both stores moved to Central Plaza Shopping Center and, along with the now-gone A&P supermarket, anchored the shopping center. Family Dollar still operates in that location. (Courtesy of Charles Paty.)

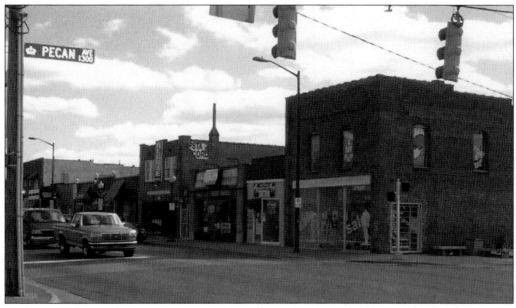

Looking southeast, this contemporary photo shows the original Long's Grocery location and the tiny building to its left that housed W.T. Harris's food store. This was the main block of the original streetcar strip that made up Charlotte's version of the "Miracle Mile." It is, with the exception of the North Davidson community, Charlotte's best-preserved example of commercial architecture built to serve streetcar and pedestrian traffic. (Courtesy of Charles Paty.)

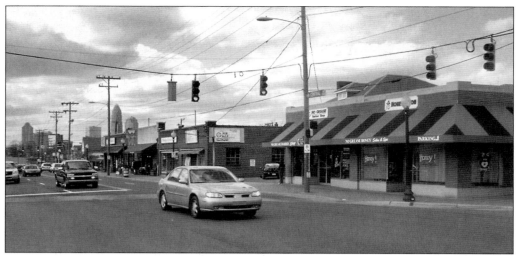

Here is a northwest view of the corner of Pecan and Central Avenue formerly occupied by the original Holy Trinity Lutheran Church. After the church's demolition, commercial buildings went up in the 1940s and 1950s, including clothing stores and pharmacies. The end unit is now the main location of an African-American–owned hair salon and barbershop. (Courtesy of Garrett Ladue.)

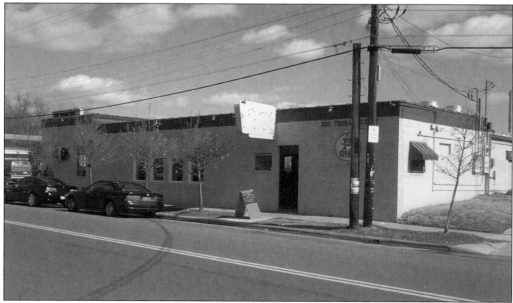

This is the present-day incarnation of Ho Toy Chinese Restaurant, sans neon sign. After Ho Toy closed, the building has housed Café Dada, an art bar–restaurant–performance space, and is now Dish, a popular dining destination for Plaza-Midwood, Chantilly, and Elizabeth residents. (Courtesy of Garrett Ladue.)

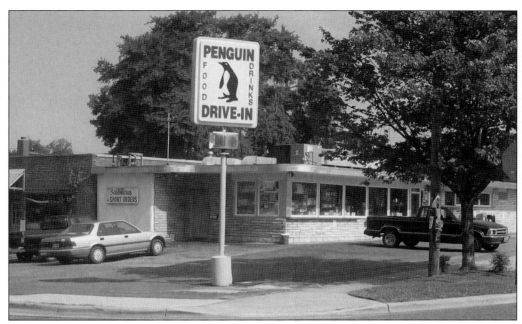

Restored to its 1950s glory by new ownership, the Penguin consistently draws large and eclectic crowds. The architecture is pure automobile-era vernacular, and its popular menu gives a nod to local barbecue traditions and 1950s nostalgia. Plaza people are treated to the Penguin's annual Fourth of July fireworks and concert. Originally built as a post office in the 1940s, the structure below is now Thomas Street Tavern, a popular local watering hole. The building is adjacent to what was once the farmhouse renovated by Paul Chatham as a base of operations during his development of Chatham Estates. (Above courtesy of Rich Snyder; below courtesy of Garrett Ladue.)

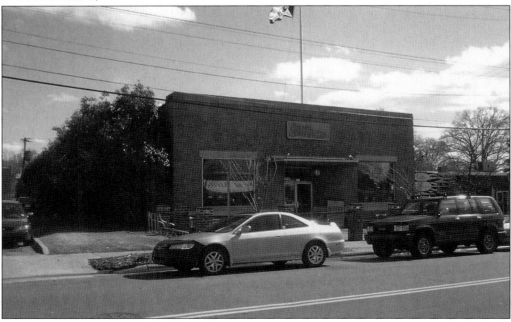

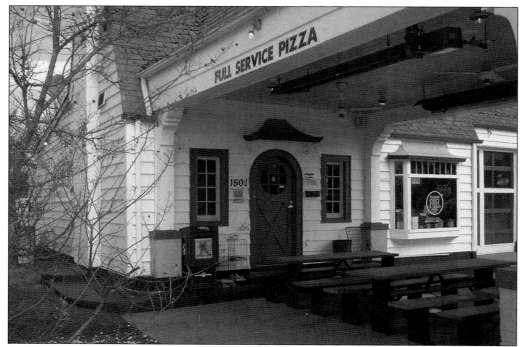

This Tudor-style building now housing Fuel Pizza was originally built in 1936 as a Pure Oil service station. The Pure Oil Company operated service stations during the early days of automobile traffic and designed many of their franchises in this domestic style, with an eye to blending into residential areas. (Courtesy of Charles Paty.)

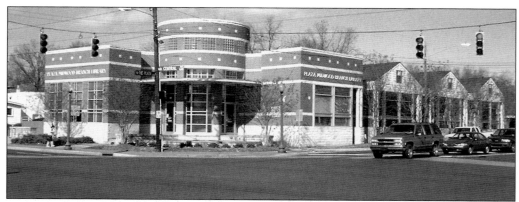

Built in 1996, the Midwood Branch of Charlotte Mecklenburg Library was a welcome addition to Plaza-Midwood. Originally located on the corner of the Plaza and Commonwealth opposite the Penguin, the branch gradually became too small to serve the resurgent community. There were also issues with vagrants using the location as a place to sleep, and patrons welcomed the new facility, which now anchors the northwest corner of the Plaza and Central Avenue. (Courtesy of Garrett Ladue.)

Five

NEIGHBORS THEN

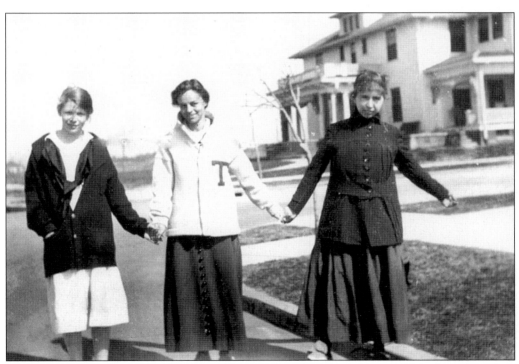

Miss Fanny Kilgo and friends play in front of the Kilgo home c. 1915–1920. At this time, when her father Bishop John Kilgo's residence was one of a few on the Plaza, these girls could stand in the street and not worry about traffic, except for the streetcars of Paul Chatham's trolley. (Courtesy of Charles Paty.)

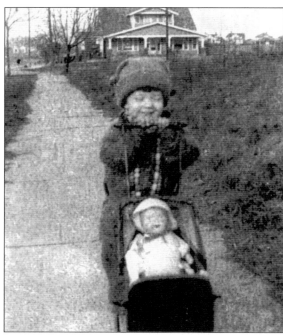

An unidentified child plays near Belevedere Avenue c. 1920s. Note the empty lots and absence of Midwood's characteristic tree canopy. (Courtesy of Charles Paty.)

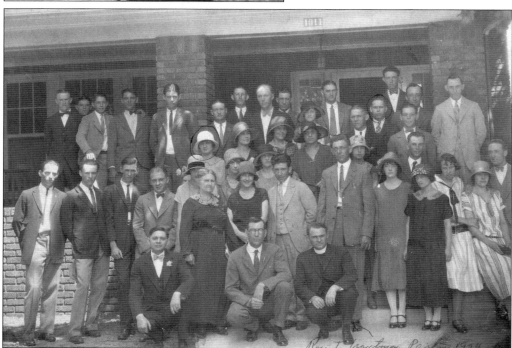

Posing in front of the parsonage at what was then 1011 Central Avenue is the Holy Trinity adult Sunday school classes sometime between 1924 and 1927. Ethel Ross is wearing a white hat in middle center with her future husband Tom Hartis, three ladies, and one gentleman to her left. By 1939, the parsonage would be designated as 1525 Central Avenue, indicating growth on Miracle Mile. (Courtesy of Holy Trinity Lutheran Church.)

Miss Mary Nisbet Alexander, seen here *c.* 1913, was a most attractive member of Pegram Street Presbyterian. Nothing is known of Miss Nisbet's occupation, but many young women experienced their first taste of freedom in the years during World War I, but for years prior, women and children worked long hours in the cotton mills of the Belmont community. Further east on the Plaza, the daughters of Charlotte's New-South elite planned their engagement calendars. (Courtesy of Plaza Presbyterian Church.)

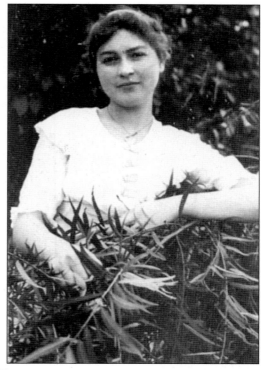

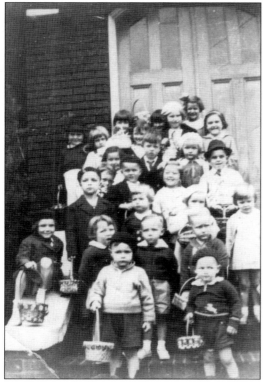

The names of these children are lost to time, but we know by the baskets that the photo was taken at Easter on the steps of Plaza Presbyterian *c.* 1926. At the time these children would likely have attended school at either Elizabeth Graded School or Villa Heights Elementary, depending on where they lived. (Courtesy of Plaza Presbyterian Church.)

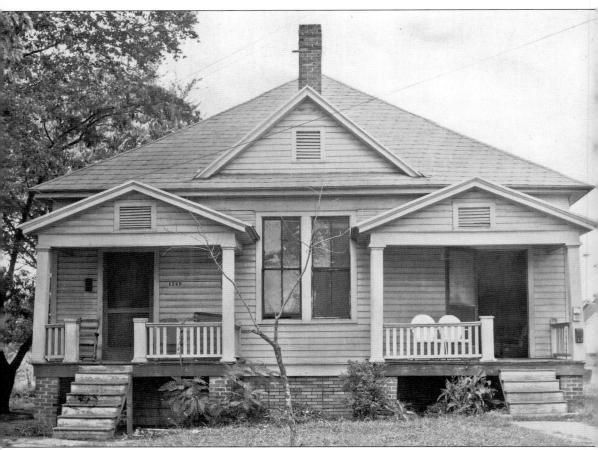

This structure housed the first congregation of one of Plaza-Midwood's most influential churches, Plaza Presbyterian. Initially organized as Pegram Street Presbyterian in 1907, the congregation met above Spoon's store and the Woodmen of the World Hall on Pegram Street in the Belmont community. The Louise Mill Company donated a lot on the corner of Pegram and St. George Streets for construction of the first church. (Courtesy of Plaza Presbyterian Church.)

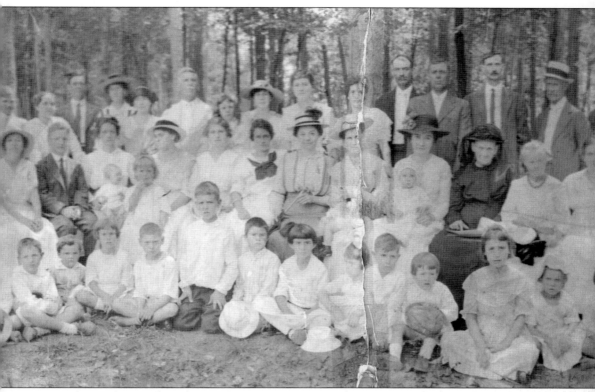

Faces from Plaza-Midwood's past gaze out at us in this picture taken at Pegram Street Presbyterian's annual Sunday-school picnic in August 1916 at Lakewood Park. The congregation, including children and elderly, would have more than likely caught the trolley system and commuter rail to the grand amusement center in west Charlotte off Tuckaseegee Road. (Courtesy of Plaza Presbyterian Church.)

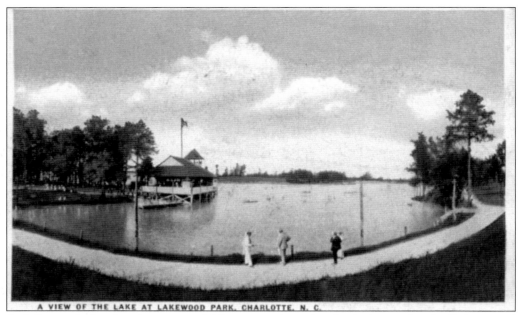

A VIEW OF THE LAKE AT LAKEWOOD PARK, CHARLOTTE, N. C.

At Lakewood, the church group could listen to a dance band, picnic, see daredevil shows and vaudeville reviews, see exotic animals, or take a turn in a row boat. The lake was washed out by a flood in the 1930s and the parks attractions abandoned. (Courtesy of Robinson-Spangler Carolina Room, PLCMC.)

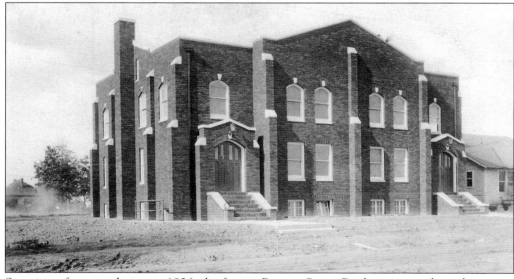

Seen just after completion in 1926, the former Pegram Street Presbyterian anchors the corner of Parkwood and the Plaza on the north end of the Plaza-Midwood neighborhood. The trolley barn for Plaza Electric Railway was nearby, in the median of the Plaza itself. The church was designed by noted Charlotte architect C.C. Hook, who designed many homes in the Plaza-Midwood area. (Courtesy of Plaza Presbyterian Church.)

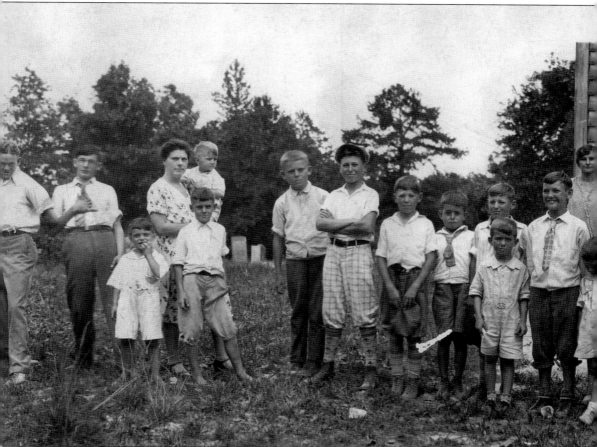

Note the hand signals of unknown meaning at the far corner of this scene from Antioch campground. These boys at Plaza Presbyterian's July 1929 picnic cut up away from the prying eyes of adults. Three months later Charlotte, like the nation, would be rocked by hard times. Neighborhood historian Charles Paty relates how people in Plaza-Midwood called on their rural past to stretch the budget. He recalls his father raising chickens and squabs at their home on Kenwood Avenue, but that the city had ordinances against pigs being kept within the city limits, as seen on deeds of the time. (Courtesy of Plaza Presbyterian Church.)

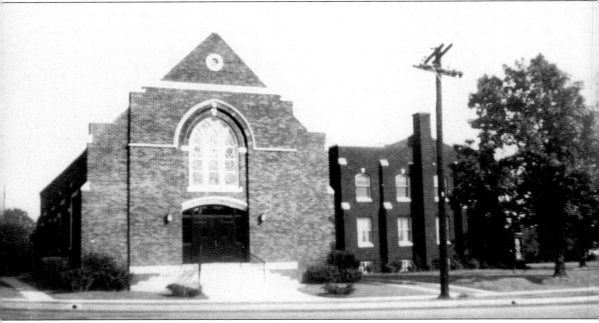

Prominent architect Louis Asbury designed this expansion of Plaza Presbyterian Church in 1941, and the first service in the new structure was held in May of that year. Asbury also designed the home of Bishop John Kilgo. In 1955, the structure was expanded and a new steeple added, bringing the sanctuary to its current appearance. (Courtesy of Plaza Presbyterian Church.)

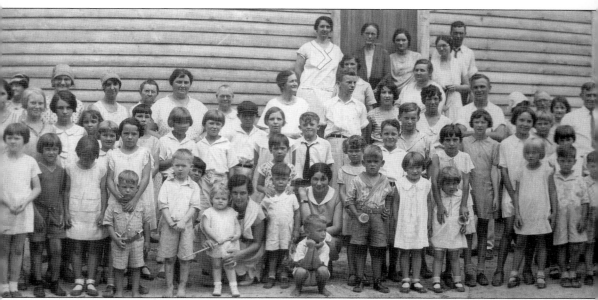

The faces of neighbors past invite us to look not at the past but at ourselves. At one time the still images drew breath. They lifted cups of coffee to their lips, smiled at their children, and were late for work. That their experience was different from ours is told in their faces. Changing customs, changing economic circumstances, and technological conveniences change the very way we carry ourselves. In most early photographs in this section—those dating from the early 1900s—you can see the last gasp of Victorianism. The stiff upper lip and the stiff collars point to a time where manners and "appropriate" behavior meant all. But the early 1900s were also a time of great violence in the South. We have seen the deep-seated race hatred evident in the simple act of buying a home. Contrast these faces from Plaza Presbyterian's 1929 picnic with the previous image from Lakewood Park—the corset is gone and children are animated. (Courtesy of Plaza Presbyterian Church.)

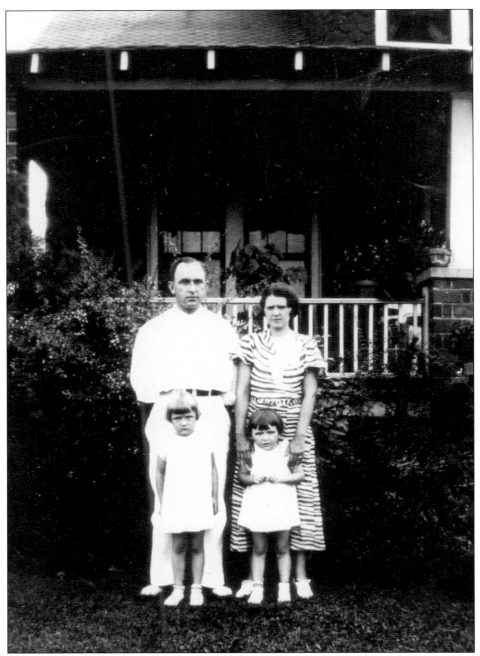

Jim Shinn, Ellen Shinn, and their daughters Ellen and Dot are seen at home on Winter Street c. 1930s. The family had moved from Mecklenburg Avenue prior to buying this home in part of the development featured in the brochure on Midwood Manor along with Belvedere Avenue. Belvedere was the road of choice for the influential members of the Charlotte Country Club. The streets in the immediate vicinity of the club would eventually hold some large estates along Club Drive, but along Winter and its sister streets, middle-class bungalow architecture prevailed. (Courtesy of Plaza Presbyterian Church.)

This bulletin dated 1939 shows the original Holy Trinity Lutheran Church on Central and Pecan. Announcements include meeting of the Women's Missionary Society at the home of Mrs. Hovis at 1323 Thomas Avenue. The sermon was on "Realism and Christian Faith." The reality of war would soon reach the neighborhood in the form of draft notices and dreaded telegrams. (Courtesy of Holy Trinity Lutheran Church.)

Holy Trinity Evangelical Lutheran Church

CENTRAL AND THOMAS AVENUES
CHARLOTTE, N. C.

REV. OLIN W. SINK, PASTOR

REV. R. L. PATTERSON, D. D., PASTOR EMERITUS

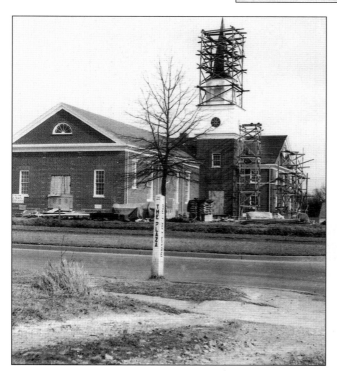

Here we see the new Holy Trinity Lutheran Church nearing completion. Holy Trinity moved to its present location in 1950 at the corner of Belle Terre and the Plaza. The colonial design was carried out by the Wagoner Group of Salisbury after termination of a contract with the prominent Charlotte firm of Odell and Associates. (Courtesy of Holy Trinity Lutheran Church.)

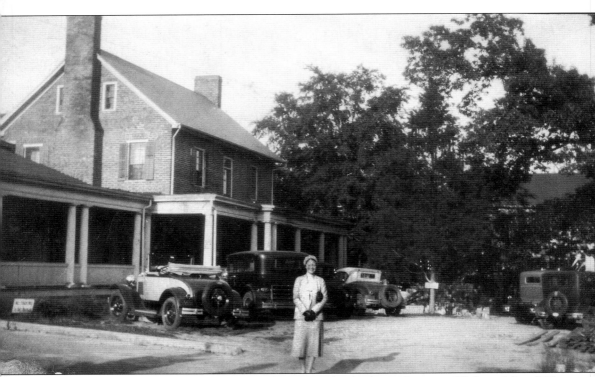

The woman in the circular drive of the original Charlotte Country Club is Mrs. W.I. Henderson, known as Dit, the mother of Charlotte real-estate developer Perrin Henderson. This picture, taken in 1931, shows the club just before it was redesigned by renowned architect Aymar Embury in a Capital Federal Revival style. The original clubhouse was a remodeled farmhouse, which stood here when club developers purchased the site in 1910. (Courtesy of Perrin Henderson.)

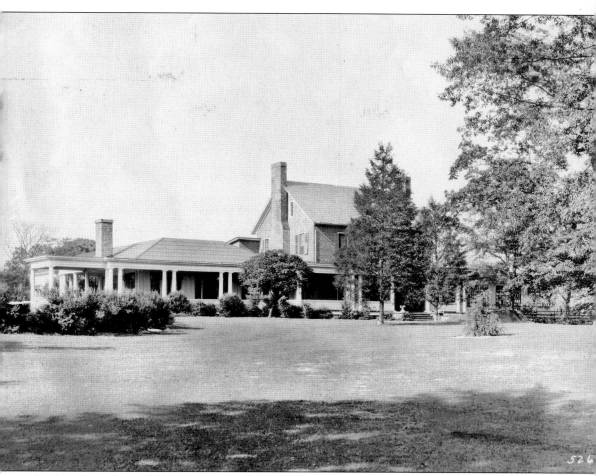

In this photo from 1931, one can see the original farmhouse and addition. Club membership grew both in numbers and prestige, and by 1931 the members sought a design that befitted this retreat for Charlotte movers and shakers. (Courtesy of Perrin Henderson.)

The Charlotte Country Club

cordially invites

Mr. and Mrs. W. I. Henderson

to the

Formal Opening

of

The New Club House

on

Friday, the eleventh of December

∽

Club inspection and reception in the afternoon
three-thirty to five-thirty

Dancing in the evening at nine-thirty

This 1931 card invites the Hendersons to the grand opening of the Aymar Embury–designed clubhouse on December 11, 1931. The drawing below accompanied the invitation, which also promised "dancing in the evening at 9:30." In dry Mecklenburg County, public social functions could be difficult. (Courtesy of Perrin Henderson.)

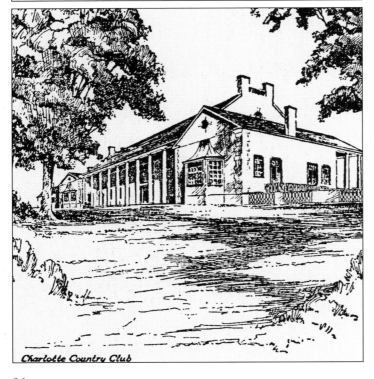

Charlotte Country Club

96

Note the old-fashioned clothes ringer in this scene from the 1940s taken by the Country Club pool. The boy to the left is Perrin Henderson. The girl is unknown. Perrin recalls his paper route along Mecklenburg and Belvedere accompanied by his dog, who would follow him to Midwood School and wait patiently for Perrin and the bike ride back. (Courtesy of Perrin Henderson.)

Taken from the back of their home at 2435 Mecklenburg Avenue, this 1946 photo shows Dit Henderson and her housekeeper Mary Miller. Early deeds from Plaza-Midwood prohibited African Americans, even those who could afford the homes, from occupying any structure in the subdivision save "outbuildings" occupied but not rented or owned by "servants." (Courtesy of Perrin Henderson.)

Both 1947 scenes were taken at Halloween festivities on Mecklenburg Avenue. The cigar-smoking accordionist at bottom right is Perrin's father, W.I. Henderson. W.I.'s family had lived on posh East Avenue, along the same stretch of prime real estate as Paul Chatham and John Van Landingham. (Courtesy of Perrin Henderson.)

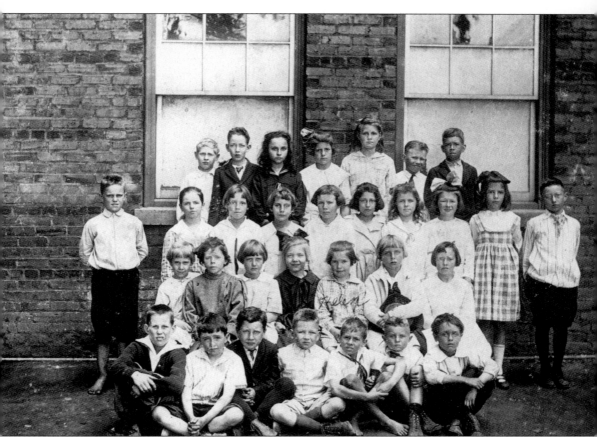

This 1907 photograph of unknown children was taken at the Elizabeth School south of Plaza-Midwood. Until Midwood School was built in the 1930s, children from many areas in Plaza-Midwood attended this school. Others attended Villa Heights north of the Plaza across Parkwood. (Courtesy of the Robinson-Spangler Carolina Room, PLCMC.)

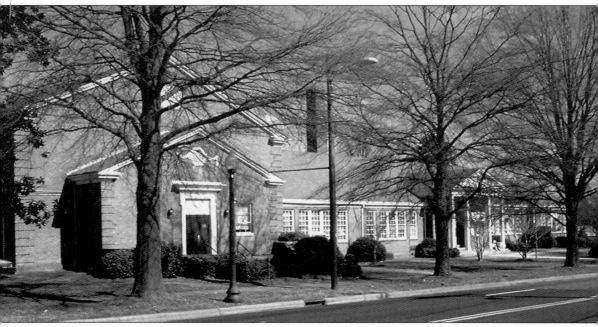

Midwood school was designed by prominent Charlotte architect M.R. Marsh, who also designed its companion school, Eastover Elementary, off Providence Road, and the Plaza Theater. The school also served as a meeting place for Green Memorial Baptist Church, prior to construction of its first location on the Plaza. (Courtesy of Garrett Ladue.)

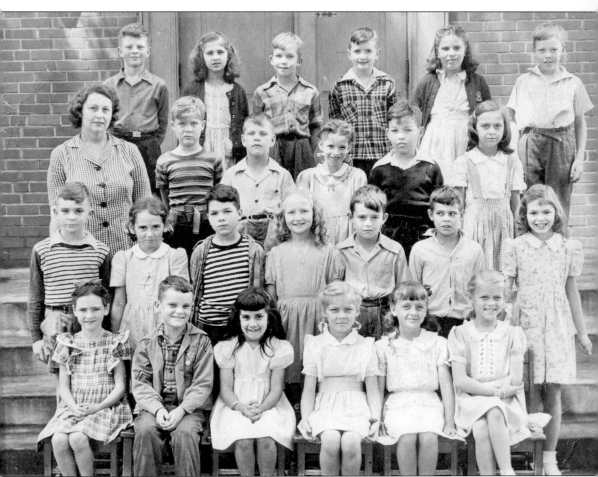

Shown here is the 1946 Midwood School third-grade class. John Lomax, first row, second from the left, recalls principal Eva Birch was firm but loving. He also recalls that children there had no concept of social standing and that they weren't overly concerned with "who had what." Though closed to African Americans by segregation laws, the school was attended by the children of the Syrian-born owner of the landmark Townhouse restaurant, Mr. Salem Suber. Mr. Lomax remembers the completion of Independence Boulevard, which went through Plaza-Midwood's business district and the neighboring Chantilly neighborhood. (Courtesy of John Lomax.)

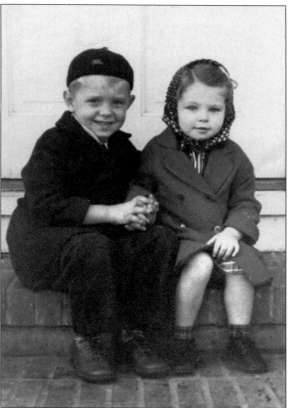

The two mischievous characters in this 1940 photo taken on Chatham Drive are Joe King, at left, and Jimmy Martin. The bottom photo shows Jimmy and first love Mary Beth Evans c. 1940. James remembers how involved neighbors were in raising each other's children, and that if you got by one you'd get caught by another. He also recalls the crash of Lt. Bud Andrews, who during World War II crashed his plane into Briar Creek rather than bale out and risk the plane hitting houses along Morningside—this despite the fact that he was heading to Pennsylvania to see his newborn baby. (Courtesy of James Martin.)

The little guy to the left of his grandfather, Mr. Peter Haskey Crenshaw, in this 1924 photo is longtime Plaza-Midwood resident Marshall "Link" Crenshaw. Like many Charlotteans, Link grew up in rural Mecklenburg County—in his case near the Cabarus line, where his father was a sheriff, farmer, and small store operator. (Courtesy of Link Crenshaw.)

The little girl at the bottom right of this photo is Link Crenshaw's wife Estelle, seen here with her mother and siblings on their Cabarrus County farm in the 1920s. Her father sold parcels of his land to the builders of the Charlotte Motor Speedway. Estelle's family had a similar experience to her husband's and like many former farm children was attracted to the opportunities in booming Charlotte. (Courtesy of Link Crenshaw.)

The pretty girl in this 1930s portrait is the future Mrs. Marshall Crenshaw. Charlotte's population had doubled in the decades prior to this photo. She and her future husband would be among the thousands of rural people pouring into Charlotte from surrounding counties. (Courtesy of Link Crenshaw.)

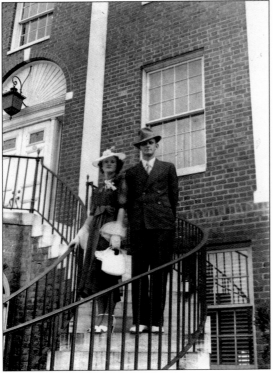

Link married his sweetheart in 1937, and the handsome couple appear here on the steps of First Presbyterian in Concord, North Carolina. They soon would move to Charlotte for job opportunities in the growing city of some 35,000. (Courtesy of Link Crenshaw.)

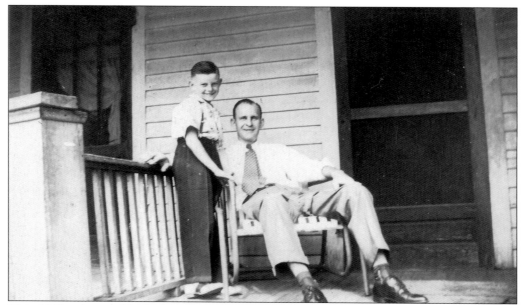

This 1940s photo of Link Crenshaw and his son was taken on the porch of a duplex the Crenshaws rented on Belmont Avenue. Link found work at the trucking firm owned by the Kilgo family. Unfortunately for the family, his son passed away shortly after this picture was taken. (Courtesy of Link Crenshaw.)

Link Crenshaw proudly served his nation during World War II in an amphibious squadron that faced heavy fighting during America's island hopping campaign in the Pacific War against Japan. He is seen here occupying the middle seat in a USO club drinking with his buddies, whose names are unknown. (Courtesy of Link Crenshaw.)

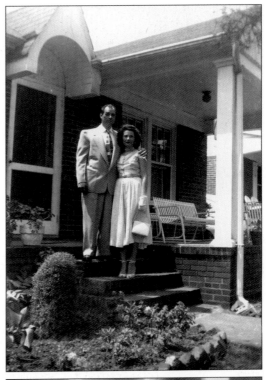

Having saved enough money, the Crenshaws purchased a home in the older section of Nassau Boulevard in the early 1950s, where he resided until his 80s, when he moved to be closer to his daughter in East Charlotte. Ironically he moved to Markham Village, off Eastway, one of the "new" suburbs that began siphoning off residents from Plaza-Midwood in the 1950s and 1960s. In keeping with his rural background, Link allowed his niece to live at the Nassau house until she found work with the *Charlotte News* downtown. She is seen in the top photo with her fiancé. At the bottom, Link's daughters Hilda (right) and Pam (left) mug for the camera in their Sunday best. (Courtesy of Link Crenshaw.)

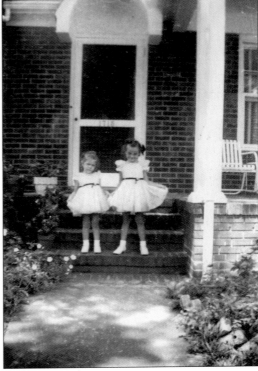

Amran Hassen came to this country around 1915, according to his daughter Mrs. Elizabeth Hassen Ferrell. He was among the first groups of non-European immigrants to Charlotte, at a time when Charlotte saw ethnicity in terms of black or white. Although he always wished to return to his home near Bethlehem in what was then Palestine, he could never save enough money to make the trip to visit his homeland. Mr. Hassen was befriended by the burgeoning Greek community in Charlotte, most of them restaurant owners. This photo was taken at Efird's department store downtown around 1924. Hassen, of Syrian origin, made his way to Charlotte from New York and joined a growing Syrian community in Charlotte, many of whom did business as fruit stand owners along with Greeks and Italians. Often, Syrian, Greek, and Italian immigrant merchants and restaurant owners were the only ones open to African Americans in Charlotte. They occupied the business area of Trade Street, near the "old" Brooklyn neighborhood inhabited by an active black community. (Courtesy of Elizabeth Ferrell.)

Mrs. Ferrell's mother Grace Keenan had gone to work in a downtown coffee shop to support her siblings, having lost her parents in the great flu pandemic of World War I. Mr. Hassen was new to Charlotte, and upon meeting Miss Keenan asked her to marry him, to which she immediately obliged. The Hassen home on Ashland Avenue was the place to go for newly arriving Syrian immigrants. "Hassen," as her father was known, taught his wife to cook Middle-Eastern style, but results were always better when Mrs. Ferrell's father took over. He sent to New York for Middle-Eastern ingredients and foods, and Mrs. Ferrell remembers the anticipated arrival of packages of baklava and other treats. Her memories of the house on Ashland also include Middle-Eastern style barbecues where whole lambs were cooked in a pit—usually on occasion of a new arrival from Mr. Hassen's homeland. According to Elizabeth, several other Syrian families made their home in Plaza-Midwood. This was a foreshadowing of the arrival of large immigrant groups in later decades, making their homes in areas adjacent to Plaza-Midwood, especially in east Charlotte. (Courtesy of Elizabeth Ferrell.)

Amran Hassen must have been very proud of his daughter's graduation from Central High in 1941. Many high-school age children attended Central. Its campus later became part of the campus of Central Piedmont Community College. Elizabeth went on to work in Washington during World War II and later for the city of Charlotte during its revitalization efforts in the Belmont community west of Plaza-Midwood. (Courtesy of Elizabeth Ferrell.)

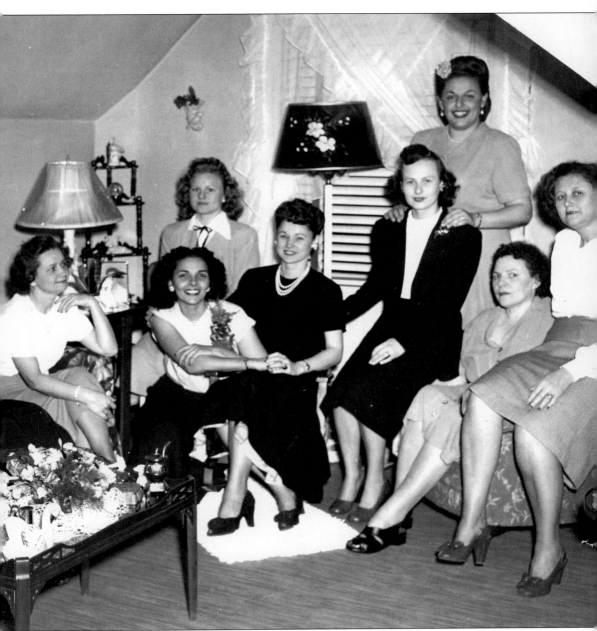

Beaming bride-to-be Elizabeth Hassen, seen here in 1948, is surrounded by friends and sister Mary Hassen (with a flower in her hair). Her future husband Zola Ferrell had been recently discharged from the army. Introduced by friends, the two met on Independence Square and spent their first date at the MiniCafé at Morehead and Tryon. As in her mother's case, she experienced love at first sight. She also recalls the small-town atmosphere in Charlotte while she was growing up in Plaza-Midwood. She and a friend would walk the length of the Midwood neighborhood from Ashland to the trolley stop, make the transfer at Hawthorne, and spend the evening downtown at the Carolina Theatre. They would return home after 11:00 p.m. sometimes and never once worry about their safety. (Courtesy of Elizabeth Ferrell.)

Mr. and Mrs. Zola Ferrell are seen here on their wedding day in 1948 on the steps of the original Kilgo United Methodist Church. Post-war exuberance and the thrill of starting a new family are written all over their faces. (Courtesy of Elizabeth Ferrell.)

Zola Ferrell, top row, far left, and unidentified coworkers at Wood's Automotive pose for a company photograph c. 1950. Like other working people attracted by more modest housing east of the Plaza along Nassau, he and wife Elizabeth purchased their home on Nassau Boulevard in the post-war housing boom. The 1920s bungalow of her father's American dream was just a short walk away. Other young families would buy lots on Thurmond, Nassau, and Hamorton, all filling in with neat cottages typical of the 1950s housing boom. (Courtesy of Elizabeth Ferrell.)

Green Memorial Baptist Church began uptown on Tenth Street in a private home, much as Pegram Street Presbyterian. The church was named in memory of Marion J. Green—a charter member—by his wife and was built on property donated by the Cole Estate, while the congregation met at Midwood School. The first pastor was W.C. Griggs, and the original church was completed in 1942. (Courtesy of Green Memorial Baptist Church.)

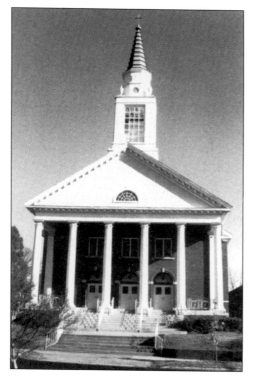

In 1952, the new sanctuary was completed. The old church was utilized as an education building until being replaced by a new building in the 1970s, giving it its present appearance. The colonial-style sanctuary stands on the corner of the Plaza and Hamorton. (Courtesy of Green Memorial Baptist Church.)

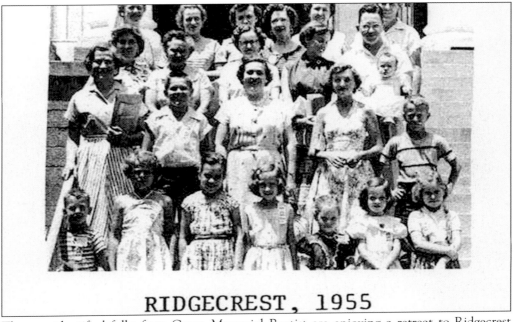

RIDGECREST, 1955

These unidentified folks from Green Memorial Baptist are enjoying a retreat to Ridgecrest campground in this 1955 photo. The church enjoyed phenomenal growth throughout the 1950s and 1960s. At this time home ownership remained stable. Only in the late 1960s and early 1970s, during the era of "white flight" in the wake of desegregation, would there be a shift to rental and cheap commercial property. (Courtesy of Green Memorial Baptist Church.)

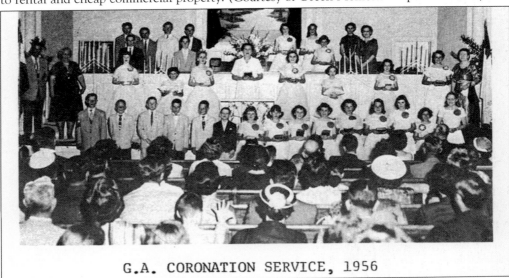

G.A. CORONATION SERVICE, 1956

Here we see the Girls in Action coronation ceremony at Green Memorial in 1956. Twenty years later, and tellingly for the neighborhood, Green was dubbed a "church in transition," a sort of at-risk status, resulting from membership loss as longtime Plaza-Midwood resident moved to newer suburbs. But like the neighborhood, Green continued to grow and rebound. Today the church is active in community outreach and provides a hot-lunch program to local seniors. (Courtesy of Green Memorial Baptist Church.)

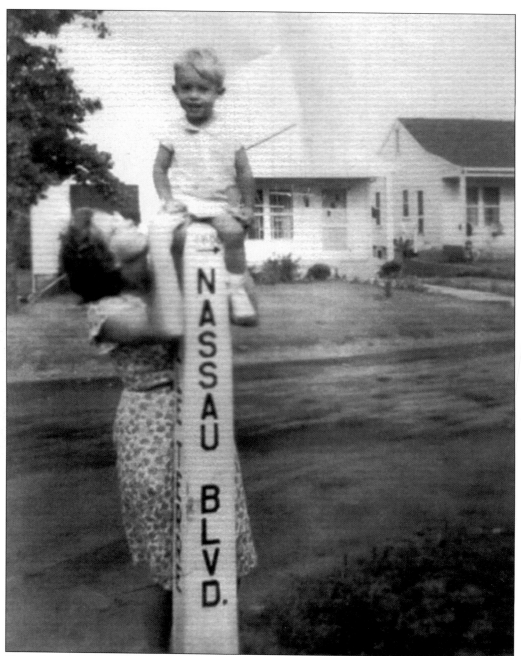

Note the concrete-pylon street sign in this scene from the intersection of Belle Terre and Nassau Boulevard c. 1948–1950; most have been removed as traffic hazards, but a few remain along the Plaza and Belvedere in the vicinity of the Van Landingham estate. The housing to the rear is a stretch of Nassau to Belvedere representing the last subdivisions of Paul Chatham's original lots—nearly 50 years after he saw his dream in a strawberry field. Young families in the post–World War II era would purchase neat brick and frame houses along Nassau, Thurmond, and Hamorton in pursuit of their dreams. (Courtesy of Marshall and Charlotte Waldren.)

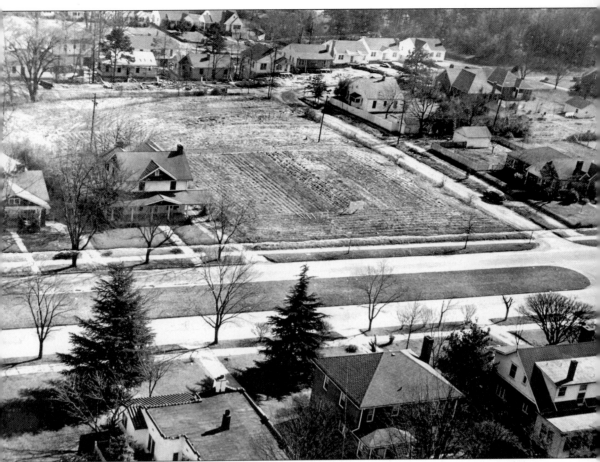

This aerial view of the corner of Belle Terre and the Plaza *c.* 1948 shows the lot Holy Trinity now occupies. In the foreground is the Plaza, showing the older homes of Paul Chatham's original plats. These homes, while not grand by the standards of the Van Landingham or Victor mansions, are obviously built for a wealthier clientele than the post-war developments of Nassau Boulevard to the top of the image. The houses under construction were part of the post-war boom that saw many young families of modest income purchasing infill homes in the older sections of Plaza-Midwood. The houses at the very top of the photo line the cul-de-sac made up by Thurmond Avenue. The area between Nassau and Tippah was to have been a park in the original Chatham design. Similar housing would go up on the eastern stretch of Hamorton, bringing in more young families. The older 1920s and 1930s bungalows of the small Nassau Heights and Midwood Manor sections are out of view to the right and top, along Chestnut and Tippah respectively. (Courtesy of Holy Trinity Lutheran Church.)

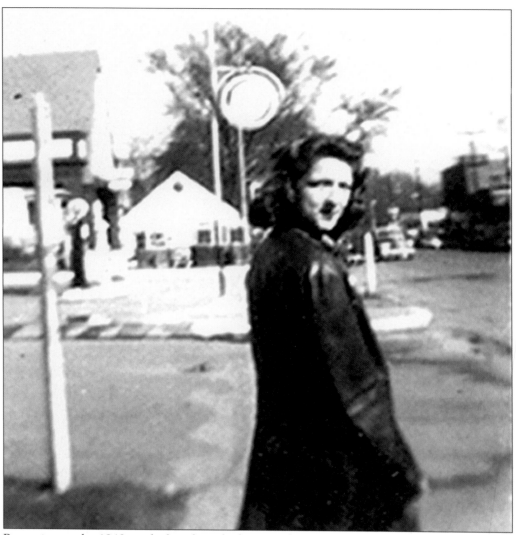

Returning to the 1940s with this photo looking northeast at the corner of Pecan, one can see over the shoulder of this unidentified pedestrian one of the seeds of Plaza-Midwood's 20-year decline in the form of Gorman's service station. Cheap and abundant gasoline and rising automobile ownership spurred a desire to live further and further away from city centers. This national trend especially affected Charlotte and caused the building of Independence Boulevard through the area separating Plaza-Midwood and Elizabeth. This traffic spurred many property owners to convert housing into cheap rentals or commercial property in an effort to "run down" properties with a view to demolishing them and building commercial development along this corridor. In the early 1970s, an expansion of Morningside Drive through the eastern edge of Plaza-Midwood was proposed and opposed vehemently by residents. They succeeded in defeating the project and their victory helped spur the formation of a strong neighborhood organization. (Courtesy of Charles Paty.)

Six
NEIGHBORS NOW

In 1970, Bill and Frances Gay, present owners of "Victoria," were sold on the home's history of removal from uptown in 1915 to the plaza. Mrs. Gay remembers her mother being upset that she would be living in a "bad neighborhood," but the price was right, so the Gays began restoring the home. Fran and neighbor Mary Anne Hammond formed the Plaza-Midwood Neighborhood Association, which for the first time gave the neighborhood a single identifiable name. Zoning restrictions were put into place and Plaza-Midwood became the first Charlotte neighborhood given a revitalization plan by the city government. The Gays were instrumental in establishing the historic district, encompassing the old Oakhurst section. Improving crime rates and skyrocketing property values reflect the Plaza-Midwood comeback. (Courtesy of Bill and Frances Gay.)

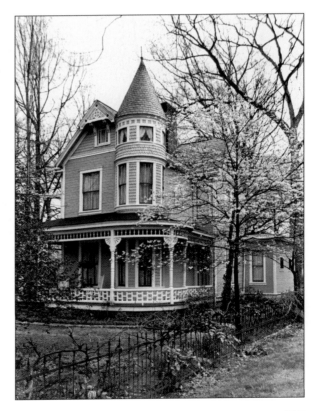

This 2003 poster advertising "Moonlight Maynia" in the Plaza-Central business district is indicative of the events sponsored by neighborhood associations. Historic walking tours, home and garden tours, Winter Fling, and especially Midwood Maynia are all popular events. There is still a great spirit of activism and ownership in Plaza-Midwood. Neighbors rally on issues such as crime, beautification, and even a winning battle against the dreaded canker worm. Vigilance by neighborhood organizers has helped to protect the lush canopy of trees, for which Plaza-Midwood is well known. (Courtesy of Garrett Ladue.)

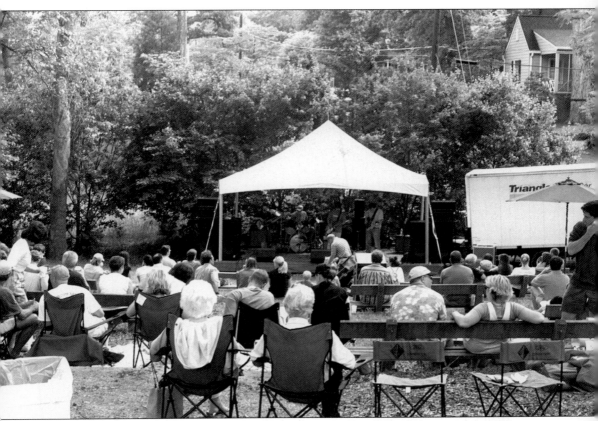

Midwood Park, pictured here during the Midwood Maynia celebration in 2000, was developed on land donated by the Midwood Men's Association in the late 1940s. (Courtesy of Garrett Ladue.)

A local gospel group works the crowd at Midwood Maynia. African Americans make up the majority of residents in areas adjacent to Midwood Park, such as Belmont, Optimist park, and Villa Heights. Many African-American families bought or rented homes in the present-day historic district adjacent to Pecan and Thomas Avenues. Many longtime black residents moved to all of these areas in the wake of the destruction of "Brooklyn"—a traditionally African-American neighborhood in downtown Charlotte—in the name of urban revitalization. (Courtesy of Garrett ladue.)

Looking southeast over the bandstand, one can get an idea of how well wooded the Plaza-Midwood area is. Contrasted with the clear-cut, cookie-cutter suburbs in some areas of Charlotte, it is understandable that there is such an influx of ready buyers for Midwood properties. (Courtesy of Garrett Ladue.)

A 1950s Charlotte Parks and Recreation guide lists barbecue areas, a baseball field, and a covered band shell as possible additions to the park. Neighbors brave the rain in this photo of a prior Maynia to listen to an eclectic mix of jazz, bluegrass, Latin, and pop music. (Courtesy of Garrett Ladue.)

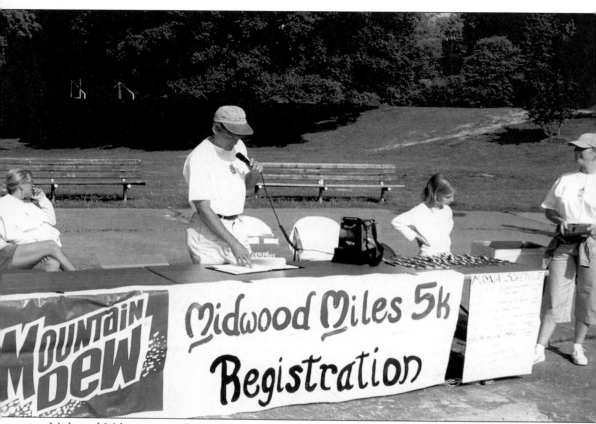

Midwood Miles is a popular event during the Maynia celebration. Area runners can test their mettle against each other in some friendly competition. (Courtesy of Garrett Ladue.)

This unidentified young Hispanic man represents a growing number of Latin-American emigrants in Plaza-Midwood and neighboring areas. (Courtesy of Garrett Ladue.)

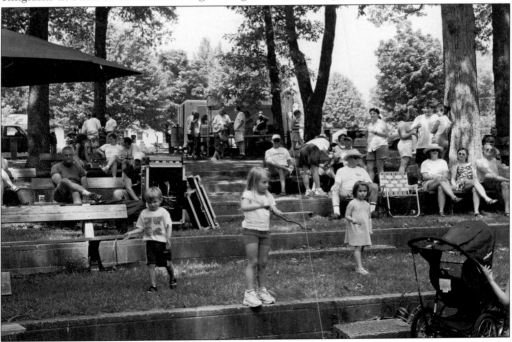

Looking toward the Midwood Park amphitheatre during Maynia young families responsible for revitalizing Plaza-Midwood enjoy the festivities. So many of these residents turned and still are turning older, often marginal properties into either moneymakers or magazine-worthy renovations. Some refer to this remake-remodel frenzy as "gentrification;" others welcome rising property values. (Courtesy of Garrett Ladue.)

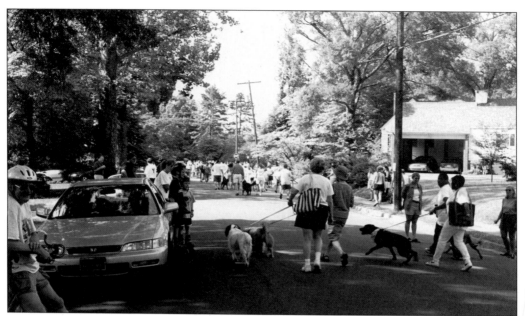

Animals are an important part of life in Plaza-Midwood, and nowhere is that better seen than at the annual pet parade. Neighbors get to show off their furry, feathery, scaly, and sometimes fishy family members at this popular spring event. (Courtesy of Garret Ladue.)

Diversity has always been a Plaza-Midwood characteristic. In the past that has been true more in terms of social status and architecture. Now, Plaza-Midwood applies diversity to people as well. Here the Charlotte Lesbian and Gay Community Center opened its doors on Central Avenue to little curiosity or protest. The neighborhood has a large gay community and is known in Charlotte for its tolerance. (Courtesy of Garrett Ladue.)

Thomas Avenue's House of Africa serves not only newly arrived immigrants from African countries such as Senegal, Nigeria, Eritrea, and Ethiopia, but also pays homage to the city's African-American community. House of Africa's sponsorship of the Juneteenth Festival celebrates the emancipation of American slaves and is a popular local festival. (Courtesy of Rich Snyder.)

Central Avenue east of Morningside Drive is now known for its large group of Asian, Latin, and Eastern-European stores and restaurants. Here, a Latin farmers' market caters to the area's Spanish-speaking residents, or anyone needing fresh cilantro. (Courtesy of Jeff Bame.)

A leisurely Sunday with neighbors is a Plaza-Midwood tradition, evidence of which can be seen here at Common Market on Commonwealth Avenue. The image is indicative of Plaza-Midwood's health as both a residential and commercial revitalization success story. The space and its adjacent block were run down for many years before being rehabbed into retail space. Common Market recalls the small "mom-and-pop" atmosphere of Long's or Harris Foods. A favorite stopping point for Plaza-Midwood people seeking a late night coffee, a bottle of fine wine, emergency party snacks, or local favorites like Blenheim ginger ale and Moon-Pies, the store—like Plaza-Midwood itself—is eclectic but rooted in its past. (Courtesy of Rich Snyder.)